July 20th.

Jennifer ...
Happy "daughters month".
♡ Love ... you ... Mom Laura + Dad Geo

MyPhotoWalk

SAVORING
GOD'S PROMISES
OF HOPE

Merry and Art Photos ...
God bless you,
In His Love,
Catherine Martin
Romans 15:13

CATHERINE MARTIN

MYPHOTOWALK
SAVORING GOD'S PROMISES OF HOPE

QuietTime
MINISTRIES

PALM DESERT, CALIFORNIA

Quiet Time Ministries has made every effort to trace the ownership of all poems and quotes. In the event of a question arising from the use of a poem or quote, we regret any error made and will be pleased to make the necessary correction in future editions of this book.

Cover by Quiet Time Ministries.
Cover photo by Catherine Martin—myPhotoWalk.com

Interior photos by Catherine Martin available at MYPHOTOWALK.COM—CATHERINEMARTIN.SMUGMUG.COM

myPhotoWalk—Savoring God's Promises Of Hope
Copyright © 2017 by Catherine Martin
Published by Quiet Time Ministries
Palm Desert, California 92255
www.quiettime.org

ISBN-13: 978-0-9979327-1-3

Printed in the United States of America

17 18 19 20 21 22 23 24 25 / ACS / 10 9 8 7 6 5 4 3 2 1

To the God of Hope
Thank you for the treasure of Your promises in Your Word
And for being the God who truly makes things happen
As You carry out Your promises in my life
And give me overflowing hope
Through the power of the Holy Spirit.

—⁂—

To all the Heroes of the Faith
Thank you for saying yes to God and His Word,
And for trusting and believing Him
In every fiery trial and raging storm.
I have learned the powerful promises of God and His Word
And how to have hope when I need it most
From your words, your books, and your lives.
To God be the glory!

❧ Books by Catherine Martin ❧

Six Secrets to a Powerful Quiet Time — A 30-Day Journey ©2005, 2014

Knowing and Loving the Bible — A 30-Day Journey ©2007

Walking with the God Who Cares — A 30-Day Journey ©2007, 2016

Set My Heart on Fire — A 30-Day Journey ©2008

Trusting in the Names of God — A 30-Day Journey ©2008

Passionate Prayer — A 30-Day Journey ©2009

Pilgrimage of the Heart — Quiet Times for the Heart ©2003, 2016

Revive my Heart — Quiet Times for the Heart ©2003, 2011

A Heart that Dances — Quiet Times for the Heart ©2003

A Heart on Fire — Quiet Times for the Heart ©2002, 2012

A Heart to See Forever — Quiet Times for the Heart ©2003, 2011

Passionate Prayer — A Quiet Time Experience ©2009

Trusting in the Names of God — A Quiet Time Experience ©2008, 2015

A Heart that Hopes in God — A Quiet Time Experience ©2007, 2011

Run Before the Wind — A Quiet Time Experience ©2008, 2012

Walk on Water Faith — A Quiet Time Experience ©2014

A Woman's Heart that Dances — A Devotional Journey ©2009

A Woman's Walk in Grace — A Devotional Journey ©2010

The Quiet Time Notebook — A Quiet Time Notebook ©1994, 2013

The Quiet Time Journal — A Quiet Time Notebook ©1994, 2012

The Devotional Bible Study Notebook — A Quiet Time Notebook ©2010, 2013

The Passionate Prayer Notebook — A Quiet Time Notebook ©2013

Quiet Time Moments for Women — A Devotional Experience ©2010

Drawing Strength from the Names of God — Devotional Gift Book ©2010

myPhotoWalk—Quiet Time Moments — Devotional Photography ©2016

Contents

Books by Catherine Martin . 6

Introduction . 9

Hope . 12

When You Long to Know Jesus . 15

When You Face Temptation . 19

When You Sin. 23

When You Are Anxious and Fearful . 27

When You Need Encouragement about Prayer 31

When Your Heart is Broken . 35

When You Feel Weak . 39

When You Are Stressed. 43

When You Feel Overwhelmed . 47

When You Fall into Despair . 51

When You Need Assurance of God's Plan 55

When You Are Grieving . 59

When You Need a Miracle . 63

When Your Life Does Not Make Sense 67

When You Need to Experience God's Power 71

When You Are Losing Hope. 75

When You Need to Wait. 79

When You Feel Your Life is Going Nowhere 83

When You Are Feeling Hurt. 87

Contents

When You Feel Alone . 91

When You Need Strength . 95

When You Feel Forgotten . 99

When You Need the Grace of God . 103

When You Are Suffering . 107

When You Suffer Persecution . 111

When You Have a Need . 115

When You Need Strength for the Impossible 119

When You Can't Let Go of Guilt . 123

When You Are Losing Heart . 127

When You Need Assurance of Your Heavenly Home 131

When You Need the Hope of Eternity . 135

APPENDIX

myPhotoWalk SmugMug . 140

Photography . 141

About The Author . 145

About myPhotoWalk . 146

Acknowledgments . 147

You Might Also Like . 148

≈ INTRODUCTION ≈

Sometimes the rain falls hard and the winds blow with hurricane force. The last five years have been like that for me. Following the death of my father a few years ago, I realized how much I needed God's encouragement from His promises. I desperately needed hope more than ever; I knew God's promises were the secret to "holding on with patient expectation." And so, I began to search for a promise in God's Word every day. I became intentional about going on photo walks with my camera to capture images of God's creation, reminding me just how powerful and majestic God really is. And, oh, how this purposeful quest for hope in God's promises has greatly fortified my heart! Then, one day in my quiet time, God gave me an idea. Why not create a little book for myself that combined favorite promises of God and photographic images captured out in God's creation? That way I could have it with me for encouragement whenever I needed a giant dose of hope. I made several copies and gave one to my mother and other close friends. And I kept one for myself. I called it "my little book of hope."

Not long after I created my little book of hope, I received the phone call that my mother had suffered a massive stroke. Day after day, I sat beside her in the hospital, knowing that soon one of my best and dearest friends on earth would be with the Lord. I was greatly in need of encouragement, and so I grabbed my little book of hope, savoring every promise, and drinking in the beauty of each image of God's creation. I found supernatural comfort and renewed strength as I walked through that heartbreaking journey of my beloved mother's homegoing to be with the Lord.

I have cherished my little book of hope time and time again since then as I have walked through more seasons of loss and suffering. And though my heart has been wounded and broken, the promises and photography have held me strong and steadfast. And that's what happens as you live in God's promises. You are enabled through God's Spirit to become brave and courageous in the truth of God's love and purpose even if you feel everything is against you.

Savoring God's Promises of Hope is the realization of my heart's desire to give you a beautiful and expanded version of my little book of hope so that you, too, can always have encouragement when you need inspiration and motivation. As you live in these devotions, my very favorite 31 essential promises of hope, you are going to experience in a new and deeper way the power of God who makes things happen. Each devotional entry includes a brief passage of Scripture, a fresh inspirational thought, and a simple prayer. I have carefully chosen devotional excerpts from more than twenty of the books I have written as companions to these favorite promises of mine from God's Word. And then, I have included some of my favorite devotional photography images to reach into the soul with the beauty of God's creation. myPhotoWalk Devotional Photography, captured at many exquisite locations, enhances every daily devotion and is available as custom prints on myPhotoWalk-SmugMug at catherinemartin.smugmug.com. To enhance your time with the promises of hope, I have also included some of my favorite hymns, poetry, and devotional writing by favorite heroes of the faith like Charles Haddon Spurgeon, Annie Johnson Flint, and A.W. Tozer.

How do you get the most from a book like *Savoring God's Promises of Hope*? Take time with each verse, open your

Bible, focus on your favorite words, phrases, and excerpts, meditate on the devotion and photography, then think about its application in your own life throughout the day. Make notes in the margins about answers to prayer or write your spiritual legacy in *The Quiet Time Notebook* or *The Quiet Time Journal*. These one page devotions will guide your focus to the unchangeable truths of God, giving you joy, peace, and confidence to live an abundant life despite trials.

Peter tells us that God has give us "great and precious promises" to "enable you to share His divine nature and escape the world's corruption caused by human desires" (2 Peter 1:4 NLT). You can know that God always keeps His promises. So you are going to see Him do great and mighty things as you walk in the light of His Word. And you will have a heart filled with hope—every promise tethering your heart to God. Paul tells us that the encouragement of the Scriptures gives us hope (Romans 15:4). Oh yes, it is true. There is always reason to hope because God never stops working in your life. God's promises are the great secret to hope.

Paul also tells us that three things last forever—faith, hope, and love (1 Corinthians 13:13 NLT). Because hope is one of those three things, you can know that as you live in these 31 powerful promises of hope in *Savoring God's Promises of Hope*, you are focusing on truths that are eternal, unchangeable, and immovable. When you build your life on the Word, you are building on a firm foundation that can survive the hurricane-force winds of a trial and seemingly impossible seasons of difficulty. For every impossibility, dear friend, there is a promise that defies the circumstance, and shows you that nothing is impossible with your great God. He is indeed the God who makes things happen. As Jesus said, "In this world you will have trouble. But take heart! I have overcome the world" (John 16:33 NIV).

God bless you as you live daily in *Savoring God's Promises of Hope*. May this devotional book become your "little book of hope," a constant companion for you through every season of your life. May the God of hope fill you with all joy and peace in believing (Romans 15:13 NASB) so that you will abound in hope and become an encouragement to others throughout the world..

In His love,
Catherine Martin

Now may the God of hope fill you with all joy and peace in believing,
so that you will abound in hope by the power of the Holy Spirit.

Romans 15:13 NASB

⁓⟋⟍⁓

And because of His glory and excellence,
He has given us great and precious promises.
These are the promises that enable you to share His divine nature
And escape the world's corruption caused by human desires.
In view of all this, make every effort to respond to God's promises.

2 Peter 1:4-5 NLT

⁓⟋⟍⁓

I thank God for the old Book. I thank God for this old promise.
It is as sweet and fresh today as it has ever been.
Thank God, none of those promises are out of date, or grown stale.
They are as fresh and vigorous and young and sweet as ever.

Latest Sermons
D.L. Moody

⁓⟋⟍⁓

HOPE

Hope—I wait for the LORD, my soul does wait, and in His Word do I hope. Perhaps there has never been a more urgent time when people need hope from the Lord. With each day's sunrise, I am eagerly "holding on with patient expectation." All of God's creation is inviting me to rejoice in hope of the glory of God. Whether red rock Sedona, giant redwoods San Francisco, historic ruins Santa Fe, or hilltowns Tuscany, the camera opens my eyes to God's wonder. As rose petals open to the sunlight of a new day, so my soul savors God's great and precious promises of hope. Courageous and confident, renewed strength amidst trials, I move from the things of this world to the things of God.

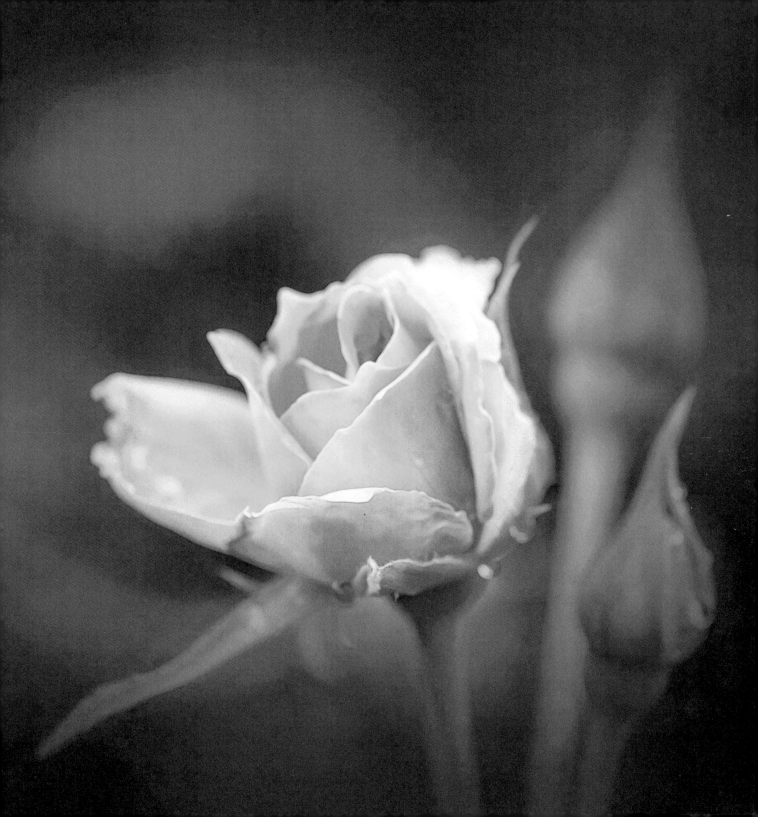

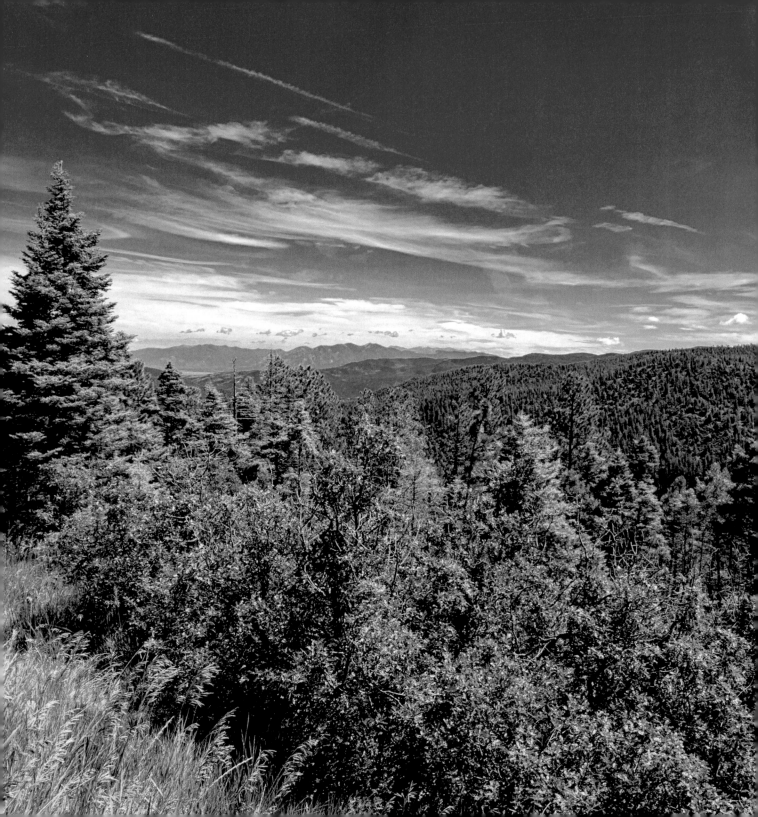

When You Long to Know Jesus

*Jesus said to them, "I am the bread of life; he who comes to Me will not hunger,
and he who believes in Me will never thirst...All that the Father gives Me will come to Me,
and the one who comes to Me I will certainly not cast out."*

John 6:35,37

There is always a moment, a point in time, when a spark is created and a fire is ignited. In the same way, as you stand at the crossroads in life, there is that defining moment when you turn to the Lord...You want to be on fire for Him, but the cares of the world have pressed in on you. Take this bend in the road as an invitation from the Lord to draw near to Him. As you begin to understand the priceless privilege of knowing Him, your love for Him will grow, and your heart will catch on fire.

A Heart on Fire — Quiet Times for the Heart ©2002, 2012

*Lord, thank You for the hope that I can always come to You
and experience the priceless privilege of knowing You. Amen.*

I need Thee every hour,
Most gracious Lord;
No tender voice like Thine
Can peace afford.
I need Thee, O I need Thee;
Every hour I need Thee!
O bless me now, my Savior—
I come to Thee. Amen.

I NEED THEE EVERY HOUR — ANNIE S. HAWKS

I am the door; if anyone enters through Me, he will be saved.

JESUS IN JOHN 10:9

Jesus—He is the sun that shines upon us, He is the star of our night. He is the giver of our life and the rock of our hope. He is our safety and our future. He is our righteousness, our sanctification, our inheritance. You find that He is all of this in the instant that you move your heart towards Him in faith. This is the journey to Jesus that must be made in the depths of the heart and being.

TOZER SPEAKS: VOLUME 1 — A.W. TOZER

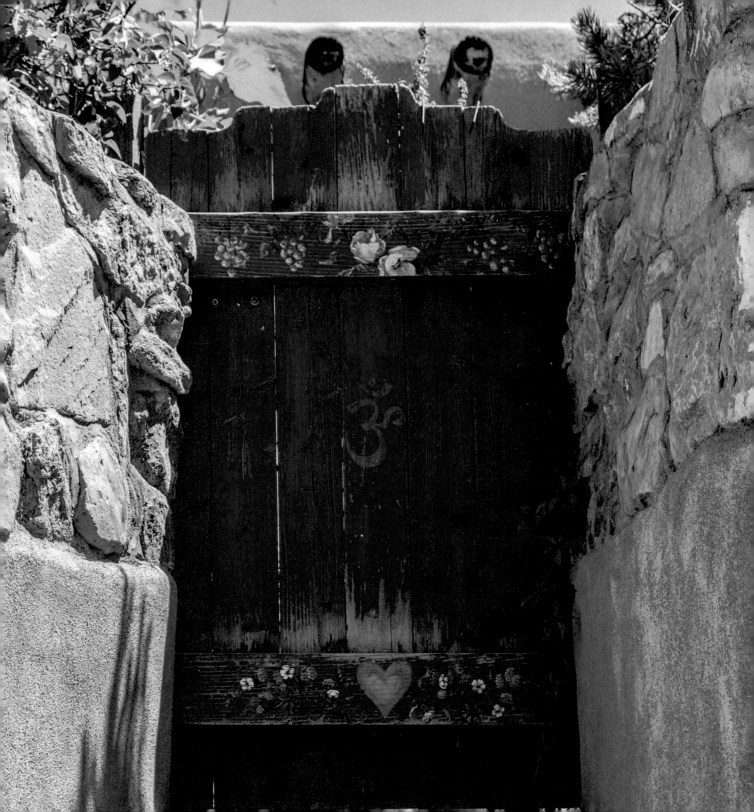

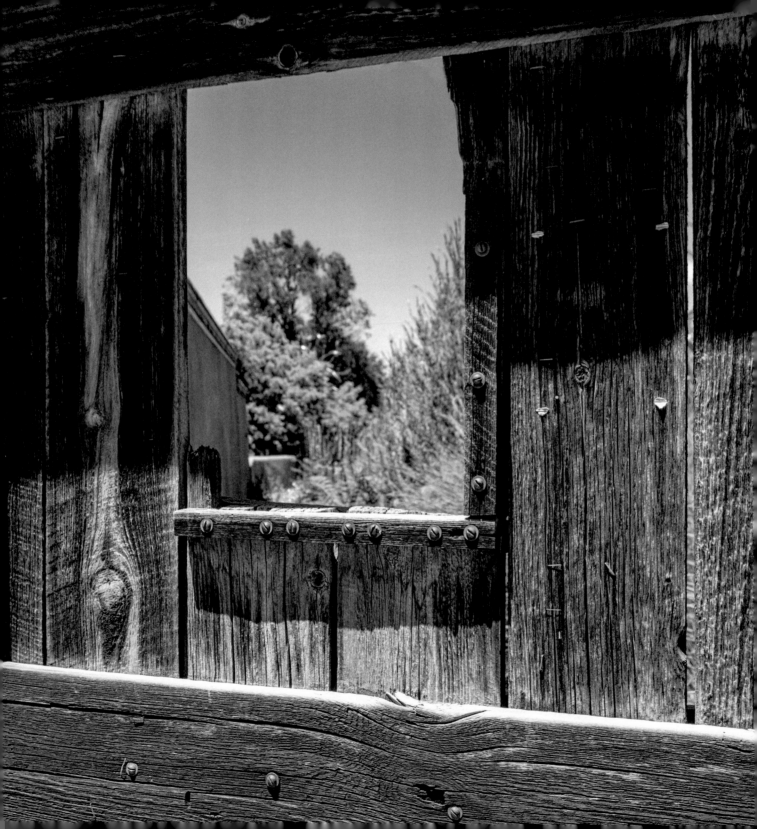

When You Face Temptation

No temptation has overtaken you but such as is common to man; and God is faithful, who will not allow you to be tempted beyond what you are able, but with the temptation will provide the way of escape also, so that you will be able to endure it.

1 Corinthians 10:13

Dependence on God means surrendering yourself, your loved ones, your circumstances, and your future to the only one who is trustworthy—God. This kind of unabashed surrender is not easy because trusting on a human level has taught us that people and things can disappoint us. But you can know that God is not like fallible human beings—He is good, perfect, loving, and faithful (Lamentations 3:22-25).

Trusting in the Names of God — A 30-Day Journey ©2008

Lord, thank You for Your faithfulness and the hope I have that You will enable me to make it through times of temptation. Amen.

I've never seen a man so wise, So great and high and grand,
So rich in houses, stocks and bonds, Or rich in cash and land,
But that he needed, needed God deep in his life and soul,
To lead and guide him on life's way to heaven's final goals.
There is no human height to reach, outside of God's good grace,
That gives assurance one may win the laurels in the race;
For high or low in human life, as we may think of man,
It's only those who walk with God that measure to His plan.

ONLY THOSE WHO WALK WITH GOD — WALTER E. ISENHOUR

Temptation victoriously met doubles our spiritual strength…Just as the wise sailor can use a head wind to carry him forward by tacking and taking advantage of its impelling force; so it is possible in our spiritual life through the victorious grace of God to turn to account the things that seem most unfriendly and unfavorable, and to be able to say continually, "The things that were against me have happened to the furtherance of the Gospel."

LIFE MORE ABUNDANTLY — A.B. SIMPSON

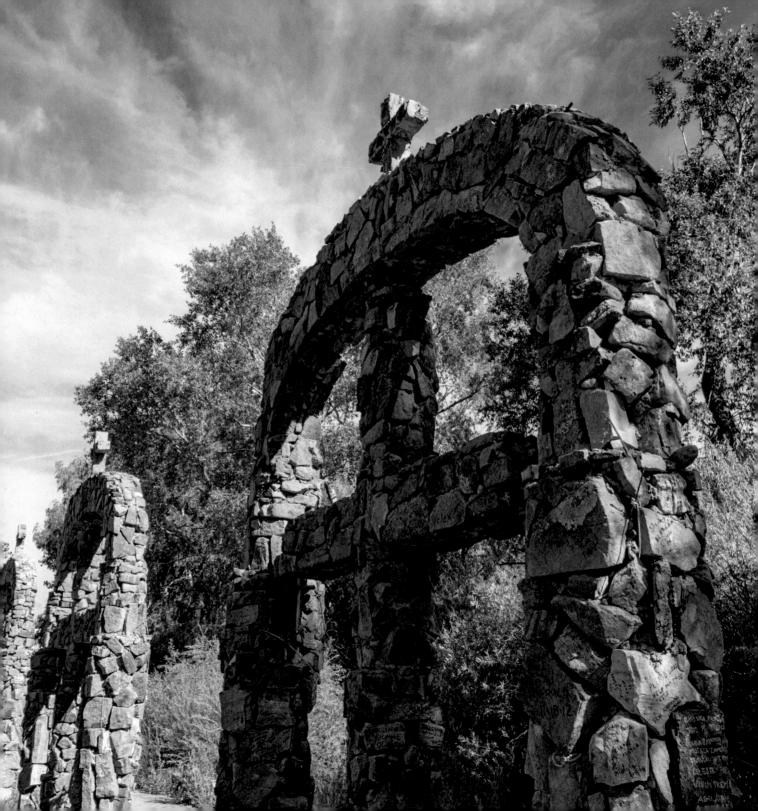

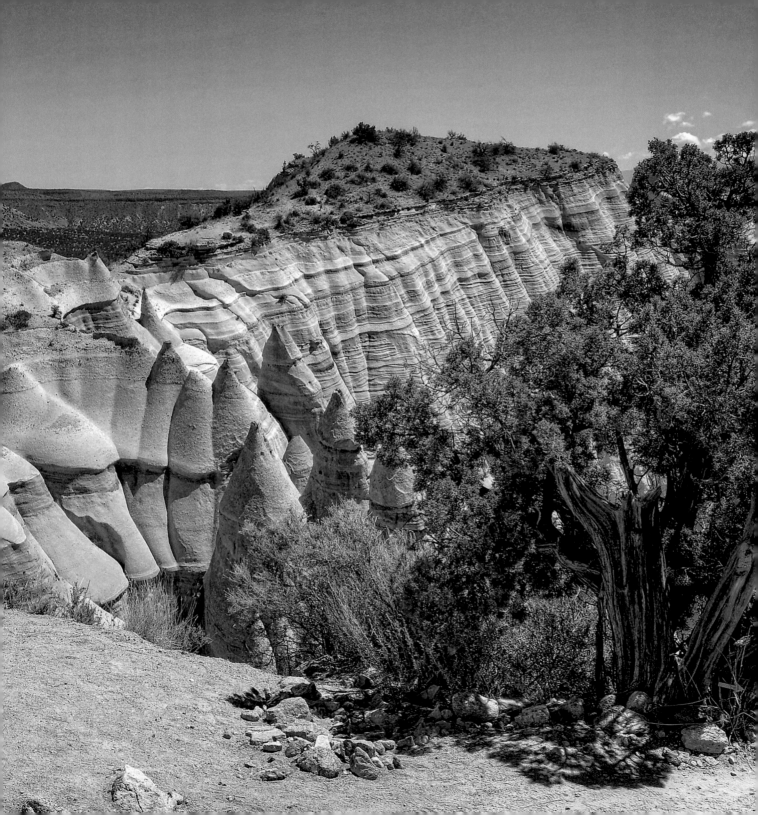

When You Sin

If we confess our sins, He is faithful and righteous
to forgive us our sins and to cleanse us from all unrighteousness.
1 John 1:9

One thing is certain. The fact that Jesus Christ broke through human history, came to earth, and died for our sins has changed the course of everything. His appearing fulfilled the prophecies of His coming and opened the way for your salvation and future of eternal life in heaven. This is one of the greatest truths in the romance of God with you. Your eternal destiny was at stake. And you were lost and without hope in the world. He did what it took to secure everything for you. All it takes is one look at God in the face of Jesus Christ and you know of His solid love for you.

A Heart on Fire — Quiet Times for the Heart ©2002, 2012

Lord, today, I confess my sin,
and thank You for the hope of Your love, forgiveness, and cleansing power. Amen.

God can "restore … the years that the locust hath eaten" (Joel 2:25); and He will do this when we put the whole situation and ourselves unreservedly and believingly into His hands. Not because of what we are but because of what He is. God forgives and heals and restores. He is "the God of all grace." Let us praise Him and trust Him.

Sunday School Times in Streams In The Desert — Mrs. Charles Cowman

Faith goes up the stairs
That love has built
And looks out the windows
Which hope has opened.

Attributed to Charles Haddon Spurgeon

God showed how much He loved us by sending His one and only Son
into the world so that we might have eternal life through Him.
This is real love—not that we loved God, but that He loved us
and sent His Son as a sacrifice to take away our sins.

1 John 4:9-10 NLT

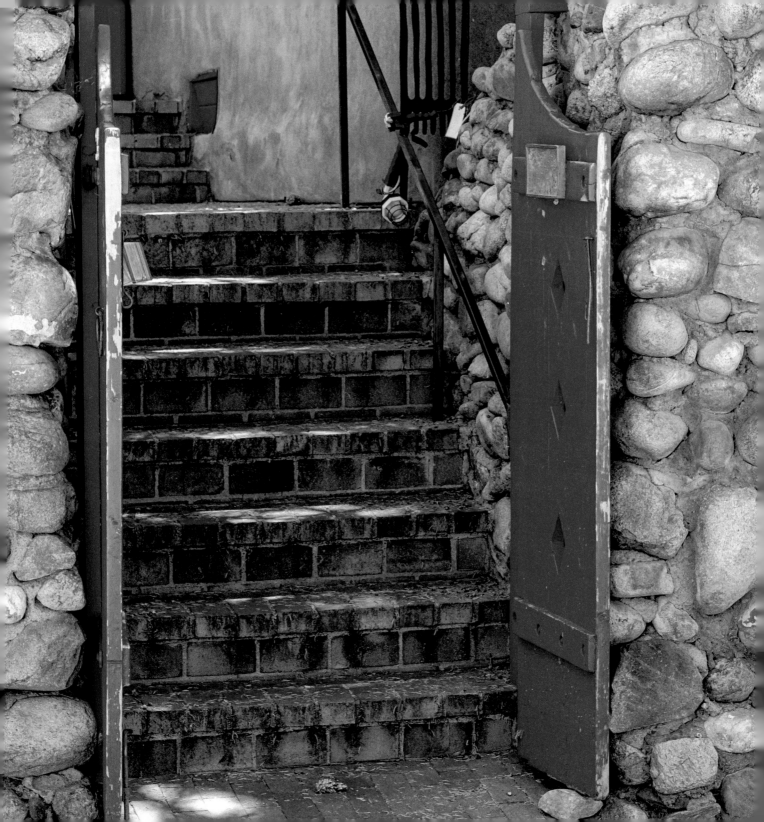

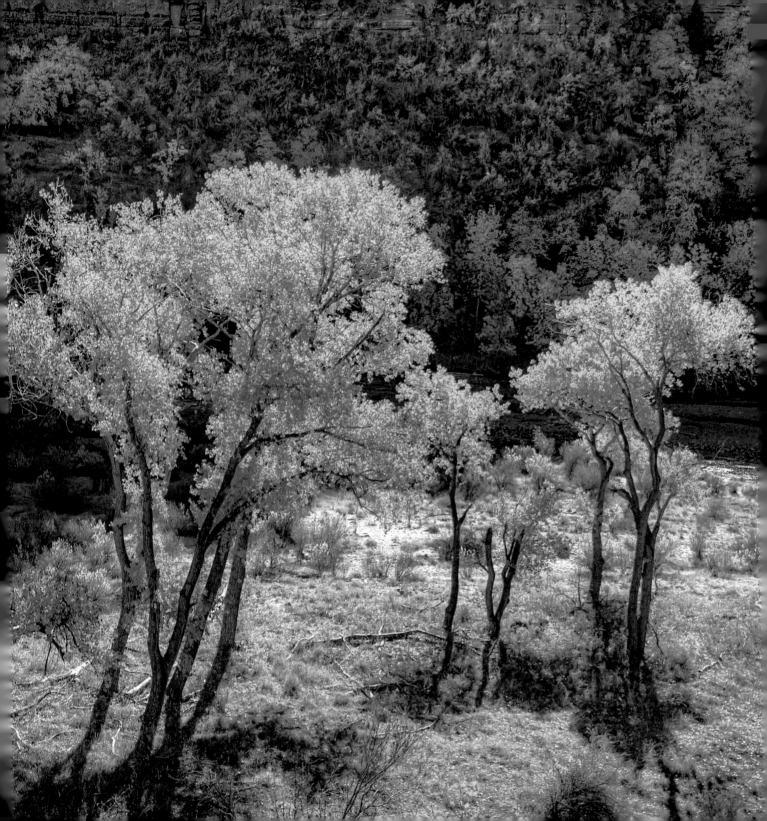

When You Are Anxious and Fearful

Be anxious for nothing, but in everything by prayer and supplication with thanksgiving let your requests be made known to God. And the peace of God, which surpasses all comprehension, will guard your hearts and your minds in Christ Jesus.

Philippians 4:6-7

Prayer is God's prescription for a troubled heart. The more you pray, the more you experience God's peace…The heart's deepest troubles require your most passionate prayers. God's peace will stand as a guard over the heart, patrolling every door of entry and blocking out all worry, anxiety, anger, and fear… Always remember, dear friend, God is never worried, anxious, or fearful. He knows what you need even before you ask Him (Matthew 6:8), and He promises to supply all your needs (Philippians 4:19).

Passionate Prayer — A 30-Day Journey ©2009

Lord, I am anxious, but I ask You to take care of my great need.
Thank You for the hope of peace You bring to my heart. Amen.

Those men who come to the bank in earnest present their checks, they wait until they receive their gold, and then they go; but not without having transacted real business. They do not put the paper down, speak about the excellent signature, and discuss the excellent document; but they want money for it, and they are not content without it. These are the people who are always welcome at the bank, and not triflers. Alas, a great many people play at praying. They do not expect God to give them an answer, and thus they are mere triflers. Our heavenly Father would have us do real business in our praying.

SPURGEON'S SERMONS ON PRAYER — CHARLES HADDON SPURGEON

⊰⊱

Happy would be our case, if we converted sufferings into prayers,
and made them gates of heaven.
Let this be our resolve. It will turn darkness into light.

DAILY PRAYER AND PRAISE — HENRY LAW

⊰⊱

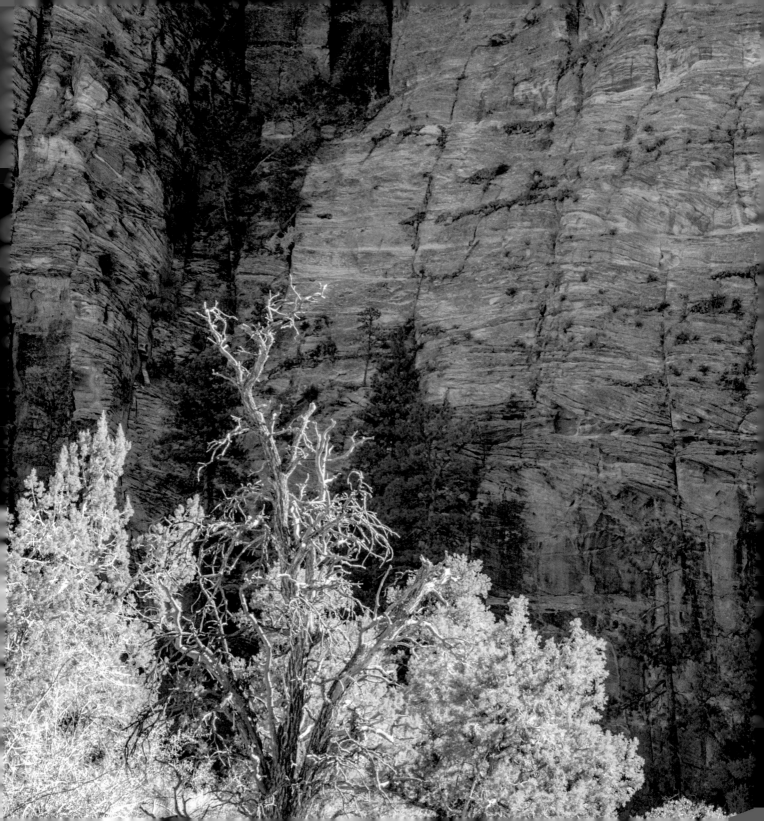

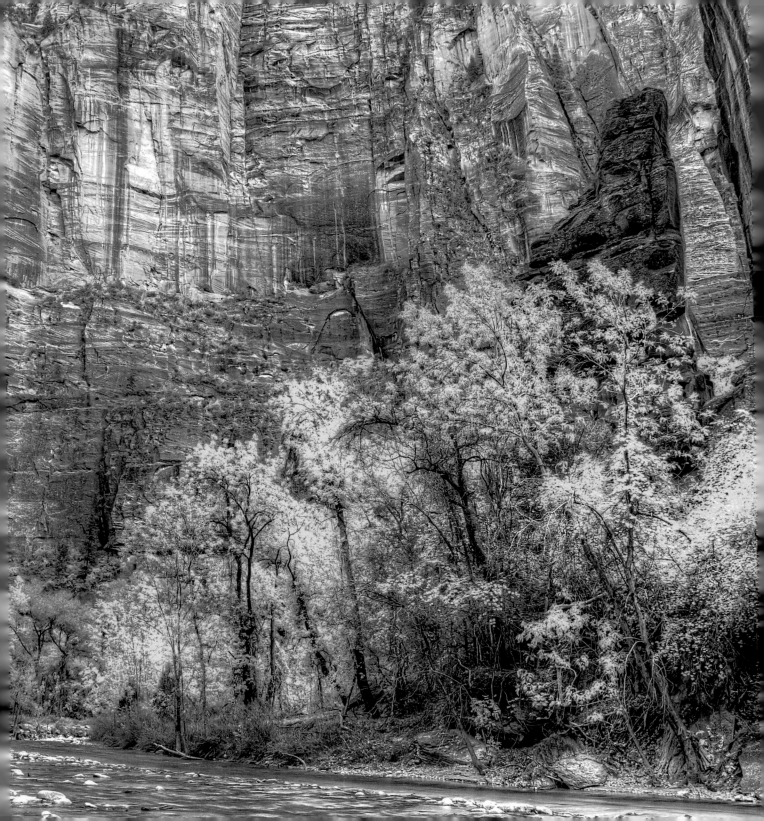

When You Need Encouragement about Prayer

This is the confidence which we have before Him,
that, if we ask anything according to His will, He hears us.
And if we know that He hears us in whatever we ask,
we know that we have the requests which we have asked from Him.

1 John 5:14-15

God is serious about prayer and responds to your humble response to His invitation to ask Him for your needs…God is waiting for you to ask Him for everything you need today. What do you need? What do you want…God has His answer for your need. How can you receive His answer? Ask Him.

Passionate Prayer — A Quiet Time Experience ©2009

Lord, I lay every single need and want before You today, and pray with hope,
expecting You to answer with Your will in Your way and in Your time. Amen.

I prayed for strength, and then I lost awhile
All sense of nearness, human and divine;
The love I leaned on, failed and pierced my heart;
The hands I clung to loosed themselves from mine;
And while I swayed, weak, trembling and alone,
The everlasting arms upheld my own.
I prayed for light; the sun went down in clouds,
The moon was darkened by a misty doubt,
The stars of heaven were dimmed by earthly fears,
And all my little candle flame burned out;
But while I sat in shadow, wrapped in night,
The face of Christ made all the darkness bright.
I prayed for peace, and dreamed of restful ease,
A slumber drugged from pain, a hushed repose;
Above my head the skies were black with storm,
And fiercer grew the onslaught of my foes;
But while the battle raged, and wild winds blew,
I heard His voice, and perfect peace I knew.
I thank Thee, Lord, Thou wert too wise to heed
My feeble prayers, and answer as I sought,
Since these rich gifts Thy bounty has bestowed
Have brought me more than I had asked or thought.
Giver of good, so answer each request
With Thine own giving, better than my best.

The Answered Prayers — Annie Johnson Flint

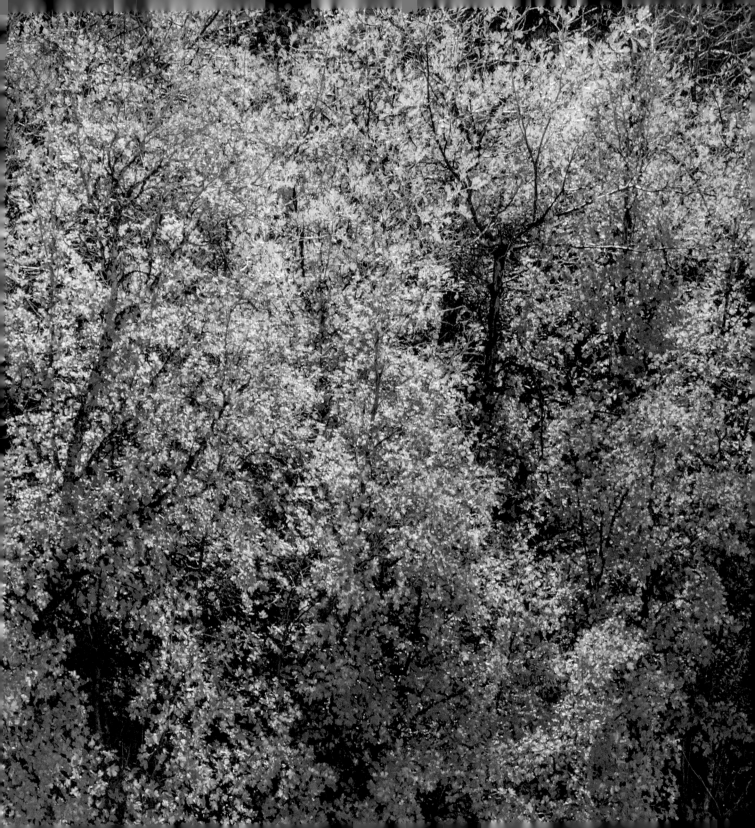

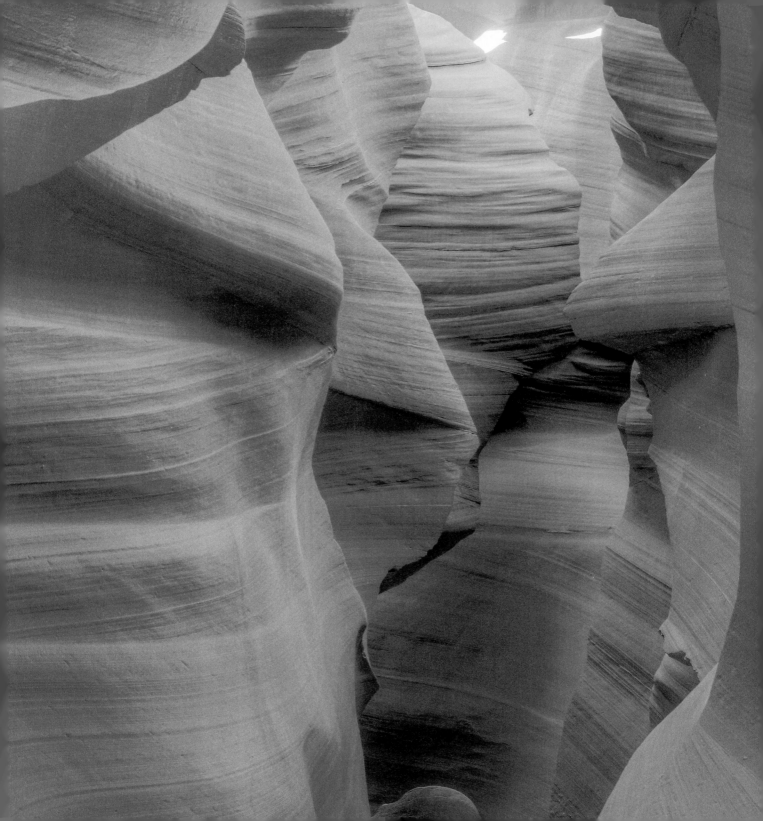

When Your Heart Is Broken

The righteous cry, and the LORD hears and delivers them out of all their troubles.
The LORD is near to the brokenhearted and saves those who are crushed in spirit.
Many are the afflictions of the righteous, but the Lord delivers him out of them all.
Psalm 34:17-19

Do you see that when you established a relationship with Christ by surrendering your life to Him you were made righteous? Your sins are forgiven and you have been given eternal life. And now you have the privileges of the righteous including prayer and intimacy with God. He is near to you and promises to save you when you are crushed in spirit. What that means for you is that when you are in what many have called the dark night of the soul, you are never alone. He is with you. As Paul said, "What shall we say about such wonderful things as these? If God is for us, who can ever be against us?" (Romans 8:31 NLT).

A Heart that Hopes in God — A Quiet Time Experience ©2007, 2011

Lord, thank You for the hope of knowing I am never alone
and You are always with me. Amen.

In the night He is preparing thy song. In the valley He is tuning thy voice.
In the cloud He is deepening thy chords. In the rain He is sweetening thy melody.
In the cold He is moulding thy expression. In the transition from hope to fear
He is perfecting thy lights. Despise not thy school of sorrow, O my soul;
it will give thee a unique part in the universal song.

Leaves For Quiet Hours — George Matheson

Is the midnight closing round you? Are the shadows dark and long?
Ask Him to come close beside you, and He'll give you a new, sweet song.
He'll give it and sing it with you; And when weakness lets it down,
He'll take up the broken cadence, and blend it with His own.
And many a rapturous minstrel among those sons of light,
Will say of His sweetest music 'I learned it in the night.'
And many a rolling anthem, that fills the Father's home,
Sobbed out its first rehearsal, in the shade of a darkened room.

Streams In The Desert — Mrs. Charles Cowman

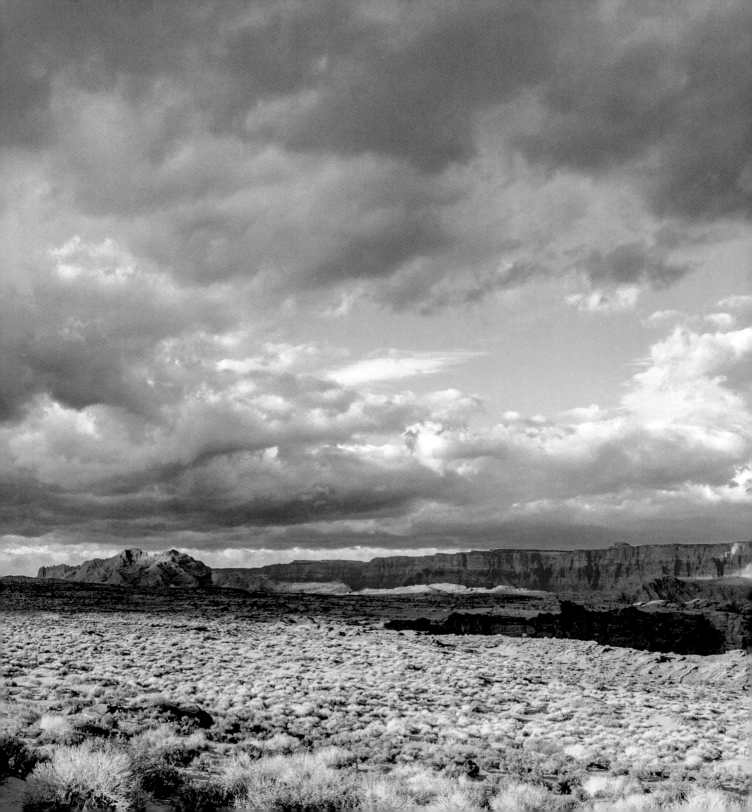

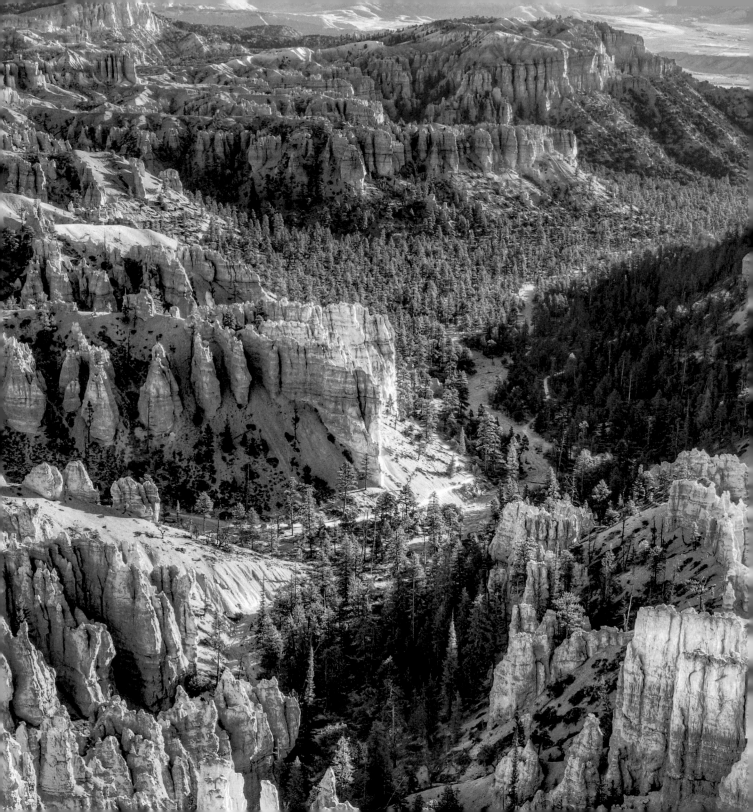

When You Feel Weak

The Everlasting God, the Lord, the Creator of the ends of the earth does not grow weary or tired…
He gives strength to the weary, and to him who lacks might He increases power…
those who wait for the Lord will gain new strength; they will mount up with wings like eagles…
Isaiah 40:28-29,31

The Hebrew word *olam* means "everlasting" and includes the immutability, the unchangeableness of God. When you think of El Olam (Everlasting God), think of the stability of God that endures forever. Everything else may change, but God never changes…To know God never changes is to have rock-solid security in the midst of ever-changing circumstances and relationships. Charles Wesley wrote, "And all things as they change proclaim the Lord eternally the same." There is one relationship you can always count on— your friendship with God.

Trusting in the Names of God — A Quiet Time Experience ©2008, 2015

Lord, I need Your strength and power. Thank You for the hope You give me in being the
Everlasting God, the One who never changes and gives me security. Amen.

There is a glorious way of escape for every one of us,
If we will but mount up on wings,
And fly away from it all with God…
The soul that waits upon the Lord
is the soul that is entirely surrendered to Him,
and that trusts Him perfectly. Therefore we might
name our wings the wings of Surrender and Trust…
Things look very different according to the standpoint
from which we view them…
The caterpillar, as it creeps along the ground,
must have a widely different "view" of the world around it,
from that which the same caterpillar will have
when its wings are developed, and it soars in the air
above the very places where once it crawled.
And similarly, the crawling soul must necessarily see things
in a very different aspect from the soul
that has "mounted up with wings."
The mountain top may blaze with sunshine
when all the valley below is shrouded in fogs,
and the bird whose wings can carry him high enough,
may mount at will out of the gloom below
into the joy of the sunlight above.

The Christian's Secret Of A Happy Life — Hannah Whitall Smith

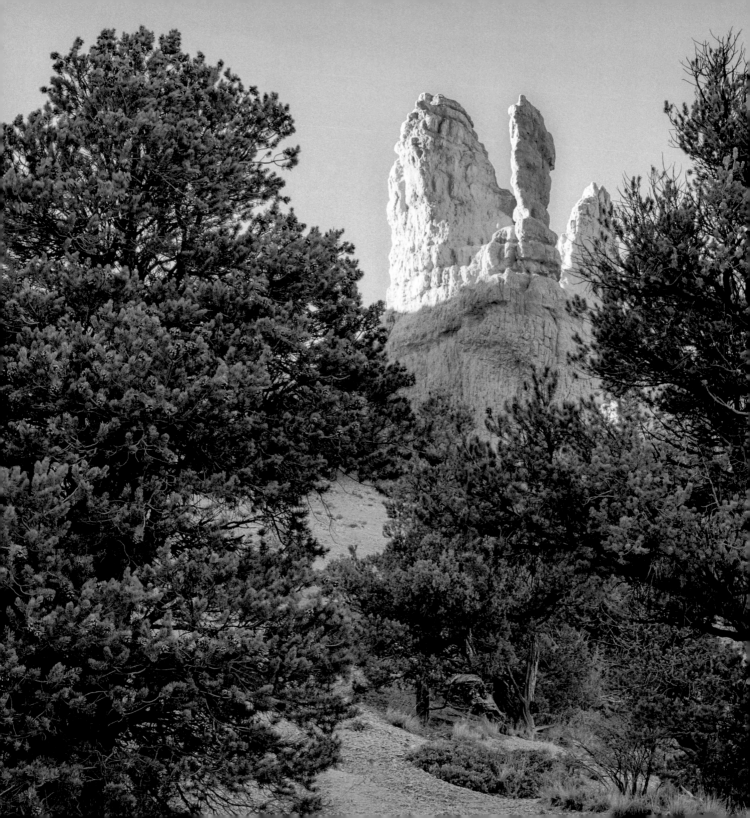

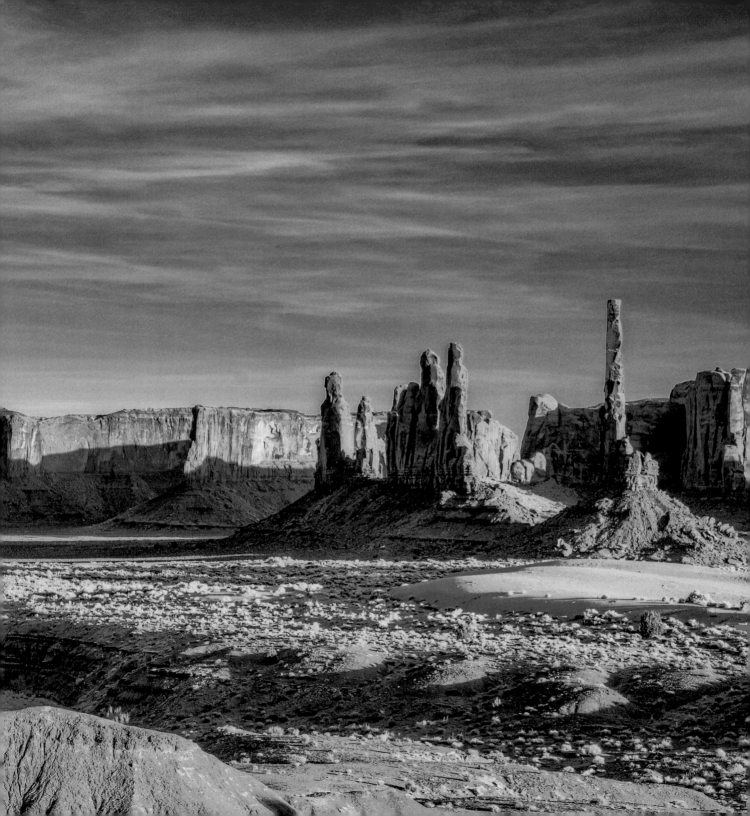

When You Are Stressed

Come to Me, all who are weary and heavy-laden, and I will give you rest.
Take my yoke upon you and learn from Me, for I am gentle and humble in heart,
and you will find rest for your souls. For my yoke is easy and My burden is light.

Matthew 11:28-30

What was it about Jesus that was so engaging, so inviting, that you would leave your daily life, alter your entire course, just to run to be with Him? Those around Him wanted to see Him, hear Him speak, and marvel at His next miracle. He constantly surprised and amazed those who followed Him...A heart on fire is a heart that burns with desire for Him—His company, His joy, His wisdom, His guidance, His teaching, and His comfort. You will discover that the fire within grows as you know Him more. Will you draw near and touch the hem of His garment today by faith?

A Heart on Fire — Quiet Times for the Heart ©2002, 2012

Lord, thank You for the hope I have from Your presence,
and for the promise of Your comfort and rest. Amen.

How firm a foundation, ye saints of the Lord.
Is laid for your faith in His excellent Word!
What more can He say than to you He hath said,
To you who for refuge to Jesus have fled.
Fear not, I am with thee, O be not dismayed.
For I am thy God, and will still give thee aid.
I'll strengthen and help thee, and cause thee to stand,
Upheld by My righteous, omnipotent hand.
When through the deep waters I call thee to go,
The rivers of woe shall not thee overflow;
For I will be with thee, thy troubles to bless,
And sanctify to thee thy deepest distress.
When through fiery trials thy pathways shall lie,
My grace, all sufficient, shall be thy supply;
The flame shall not hurt thee; I only design
Thy dross to consume and thy gold to refine.
The soul that on Jesus hath leaned for repose
I will not, I will not desert to its foes.
That soul, though all hell should endeavor to shake,
I'll never, no never, no never forsake.

How Firm A Foundation — "K" in Rippon's Selection

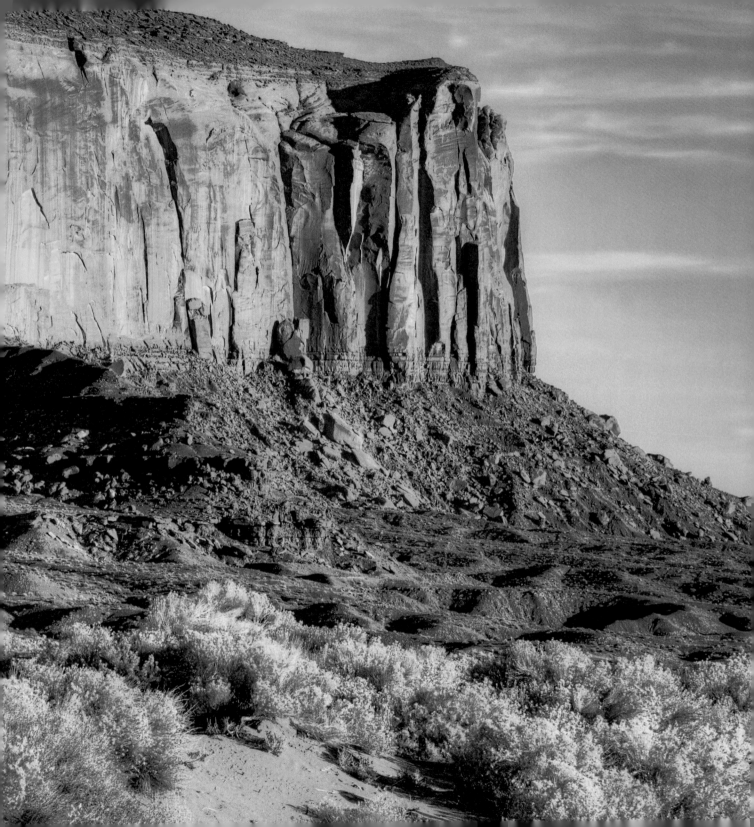

When You Feel Overwhelmed

Cease striving and know that I am God...
Psalm 46:10

Day by day, in your quiet time with God, you will learn about His attributes, His love, His power, His wisdom, His peace, His sovereignty, and more. You will understand the magnificence of His ways and purposes. As you learn these truths, you will trust Him to work in your life. You will talk with Him moment by moment. With time, you will begin to recognize His presence and power in your own life. This firsthand experience with God is incomparable, and once you have enjoyed His presence, nothing else will come close to satisfying the needs of your heart and soul.

Six Secrets to a Powerful Quiet Time — A 30-Day Journey ©2005, 2014

Lord, I want to know You.
Thank You for the promise that I may cease striving
because of Your presence and power in my life. Amen.

We need a renaissance in the art of Christian living… Indeed so little time is given to meditation that it may well be called a lost art. We have no longer time to ponder the great truths of life and destiny. With breathless haste we rush after something new among the things of time and sense, and leave no room or strength for the hour of contemplation…Haste and worry are anything but helpful to that purest devotion and loftiest thought which are essential in the making of character. He who sees God's mountains from the window of the speeding express train, or from the thronging streets of mountain cities, will never see their real glory. One must stand alone in the vast solitudes surrounded by snow-capped giants and let the mountains grow on him to experience the soul touch of majesty. And he who would know God must be much alone with God.

The Lost Art Of Meditation — John Wilmot Mahood

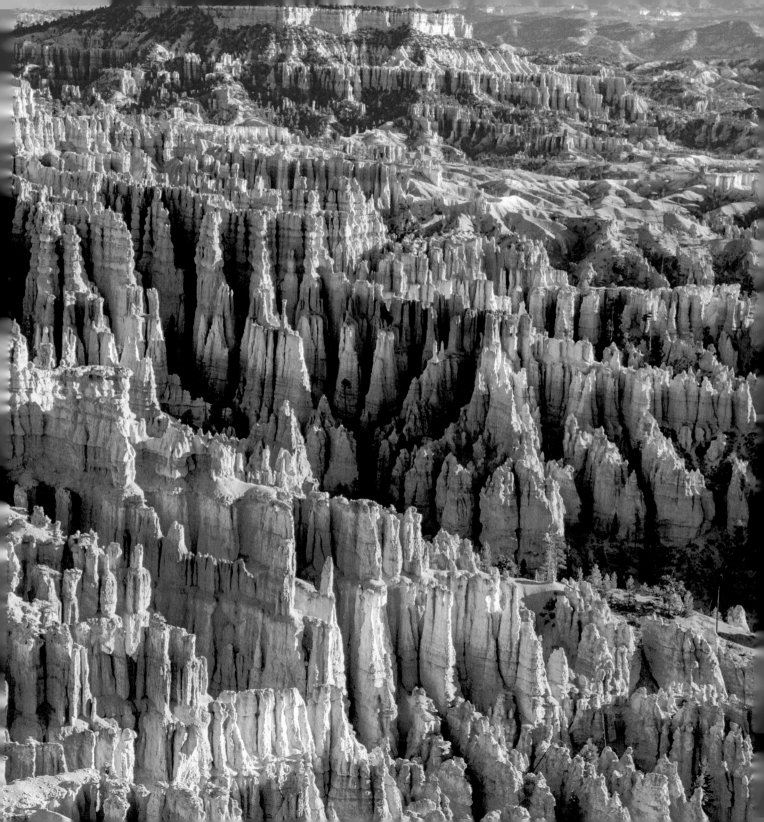

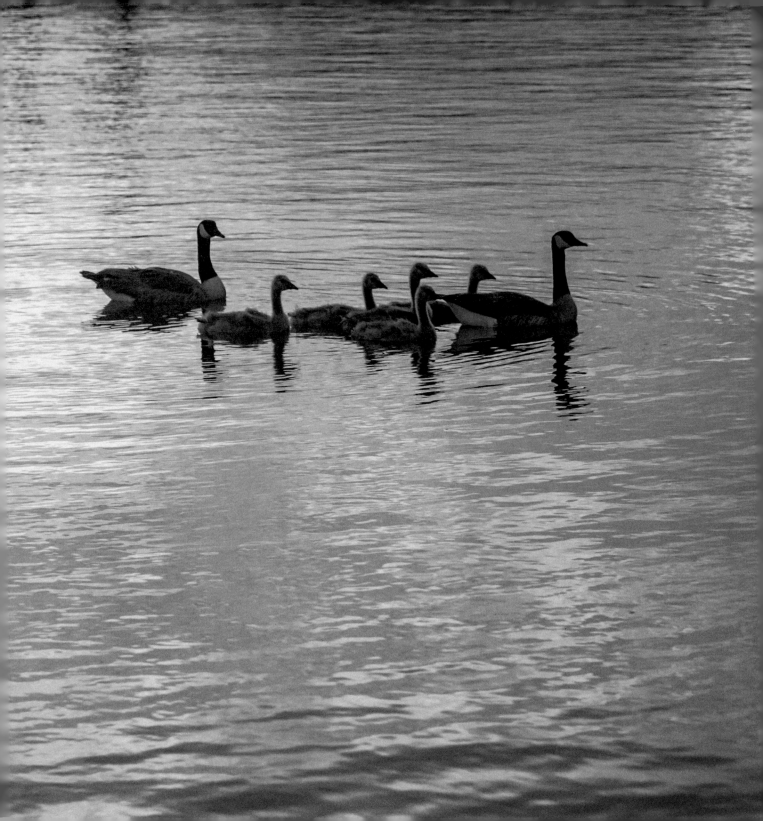

When You Fall into Despair

Sing praise to the Lord, you His godly ones, and give thanks to His holy name.
For His anger is but for a moment, His favor is for a lifetime.
Weeping may last for the night, but a shout of joy comes in the morning.

Psalm 30:4-5

Life is a journey of the heart leading you into a rich, deep intimacy with God. In your life with God, there are two certainties you can count on: trials and God. And you need to know God always outweighs any trial that comes your way. The secret to preventing a fall into despair is to calculate God into every circumstance.

A Heart that Hopes in God — A Quiet Time Experience ©2007, 2011

Lord, thank You for the hope of joy in the morning
in the face of this present time of brokenness and pain. Amen.

We make our songs in the day of our gladness,
When life is all laughter and joy and delight,
When never a shadow has clouded our sunshine;
But God giveth songs in the night.
He giveth songs in the night of our sorrow,
When tears are our drink and when grief is our meat,
Till we silence our weeping and still our repining
To list to those cadences sweet.
He giveth songs in the night of affliction,
When earth has no sun and the heavens no star;
Like a comforting touch in the desolate darkness
His voice stealeth in from afar.
He giveth songs—and His music is sweeter
Than earth's greatest voices and gladdest refrains;
Our loveliest melodies shade to the minor,
But His keep their full major strains.
He giveth songs when our music is over,
When our voices falter and our tongues are mute,
When trembling hands drop from the lute and the harp-strings,
And hushed are the viol and flute.
Give us Thy songs, O Thou Maker of music!
Teach us to sing, O Thou Bringer of joy!
Till nothing can silence the notes of our triumph
And naught our rejoicing destroy.

Songs In The Night — Annie Johnson Flint

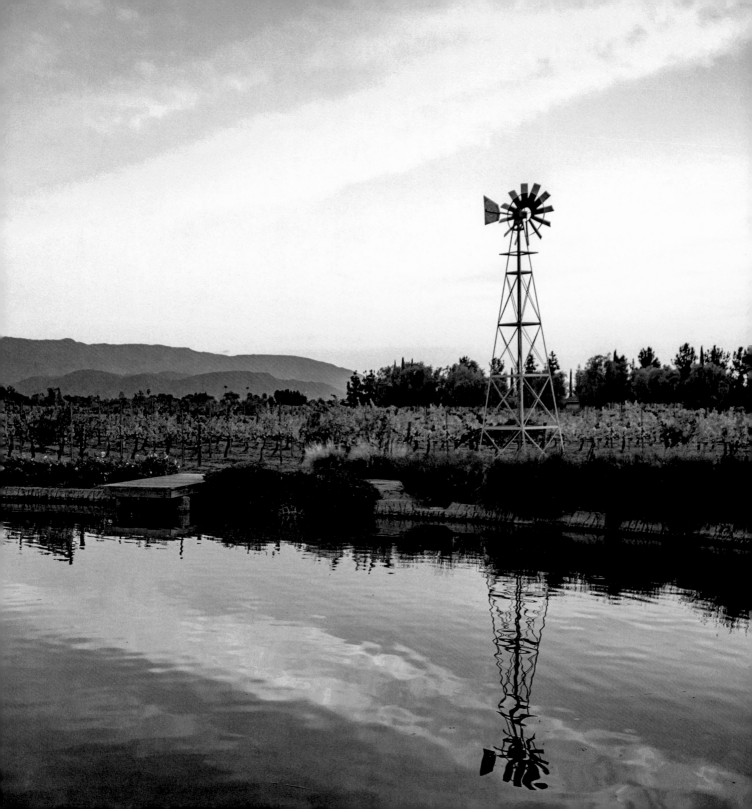

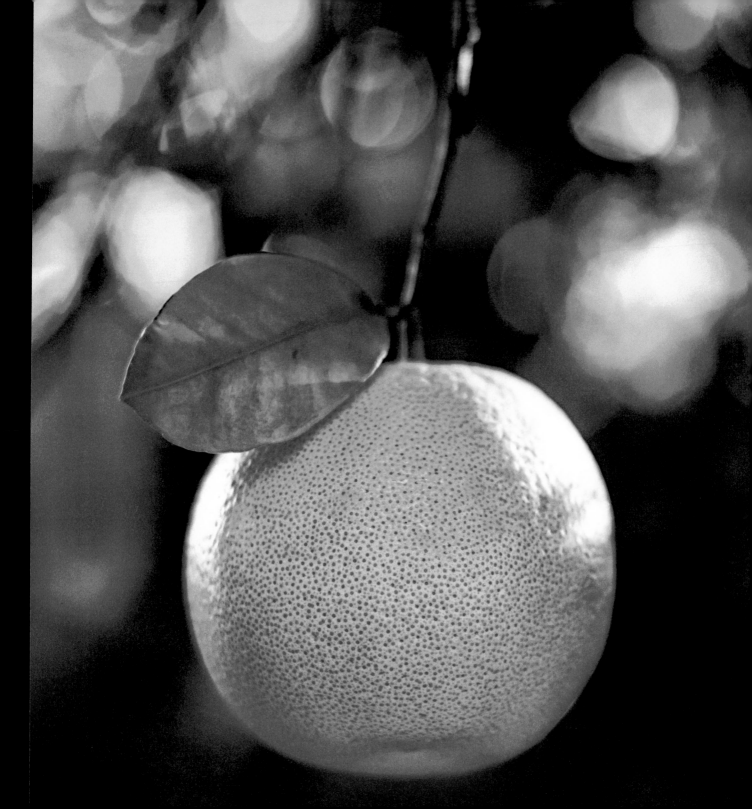

When You Need Assurance of God's Plan

For I am confident of this very thing,
that He who began a good work in you will perfect it until the day of Christ Jesus.
Philippians 1:6

What in the world is going on in my life? Have you ever entertained this thought or perhaps even spoken the words out loud? God answers your question in Paul's letter to the Philippian church. The Philippians needed encouragement and perhaps were questioning the whys of suffering—why me, why now, and why do we suffer at all? God gives an encouraging word for all harrowing circumstances. He wants you to confidently know—without a doubt—that He has begun a good work in you and that He intends to complete what He has begun. Nothing, not even your present suffering, stands in His way. What happy news for you to know that God is working in you. And He is producing something good for His glory.

myPhotoWalk—Quiet Time Moments — Devotional Photography ©2016

Lord, thank You for beginning and completing Your good work in me.
Remind me of this hope when I lose sight of my purpose in life. Amen.

Faith is dependence upon God. And this God-dependence only begins when self-dependence ends. And self-dependence only comes to its end, with some of us, when sorrow, suffering, affliction, broken plans and hopes bring us to that place of self-helplessness and defeat. And only then do we find that we have learned the lesson of faith; to find our tiny craft of life rushing onward to a blessed victory of life and power and service undreamt of in the days of fleshly strength and self-reliance.

Principles Of Spiritual Growth — James McConkey

When the Lord calls you to come across the water,
step out with confidence and joy.
And never glance away from Him for even a moment.
You will not prevail by measuring the waves
or grow strong by gauging the wind…
Lift up your eyes to the hills (Psalm 121:1) and go forward.
There is no other way.
Do you fear to launch away? Faith lets go to swim!
Never will He let you go; It's by trusting you will know fellowship with Him.

Streams In The Desert — Mrs. Charles Cowman

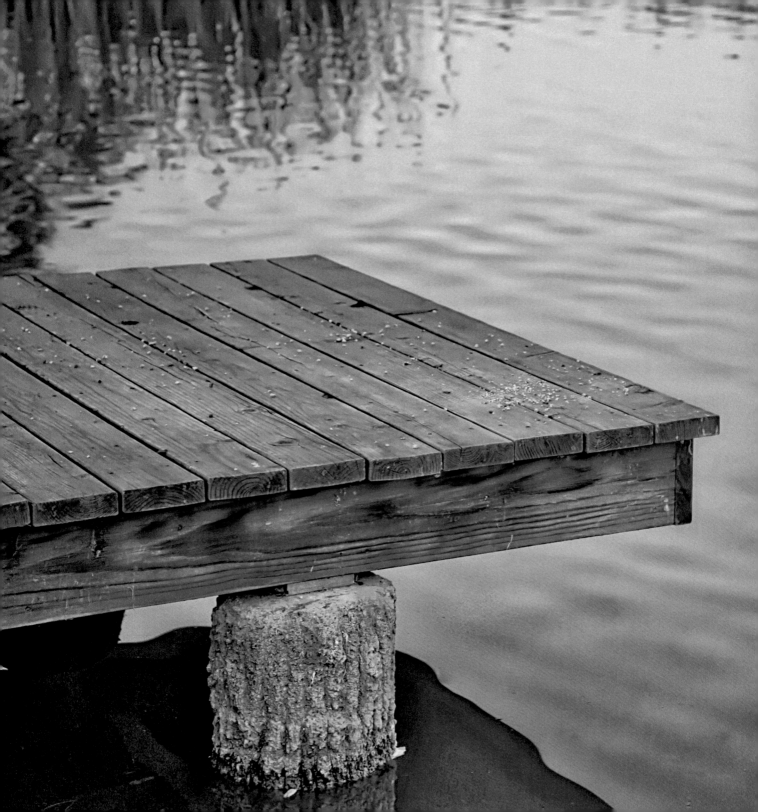

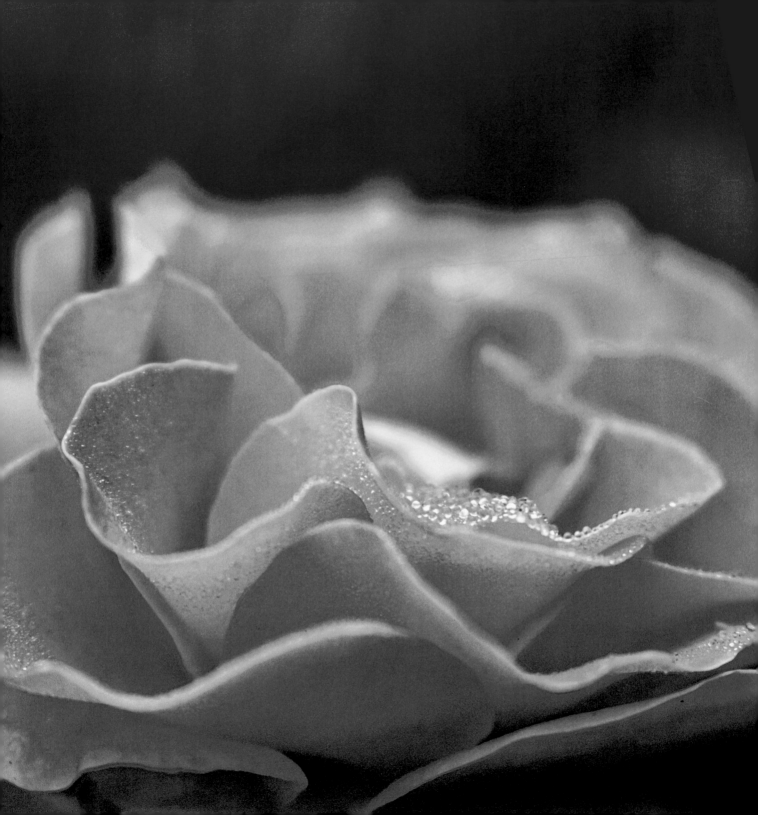

When You Are Grieving

And I heard a loud voice from the throne, saying, "Behold…God Himself will be among them, and He will wipe away every tear from their eyes; and there will no longer be any death; there will no longer be any mourning, or crying, or pain…" And He who sits on the throne said, "Behold, I am making all things new." And He said, "Write, for these words are faithful and true."

Revelation 21:3-5

Charles Spurgeon rightly observed that if God is going to wipe away all tears from our faces, then it must mean that our eyes will be filled with tears until then. He also observes that because God never changes, He is ever engaged in the drying of our eyes. He exhorts believers therefore, to never confine themselves the narrow miseries of the present hour. He says that one can never know what handkerchief God will use, but on this you can count—God Himself will wipe away all your tears. There are no tears in heaven.

A Heart to See Forever — Quiet Times for the Heart ©2003, 2011

Lord, thank You for the hope of heaven, no more tears, and all things made new. Amen.

The sands of time are sinking, the dawn of heaven breaks;
The summer morn I've sighed for, the fair sweet morn awakes:
Dark had been the midnight, but dayspring is at hand,
And glory—glory dwelleth in Immanuel's Land.

O Christ, He is the fountain, the deep, sweet well of love!
The streams on earth I've tasted, more deep I'll drink above:
There, to an ocean fullness, His mercy doth expand,
And glory—glory dwelleth in Immanuel's Land.

The Bride eyes not her garment, but her dear Bridegroom's face;
I will not gaze at glory but on my King of Grace.
Not at the crown He giveth but on His pierced hand;
The Lamb is all the glory of Immanuel's Land.

THE SANDS OF TIME ARE SINKING — ANNE R. COUSIN

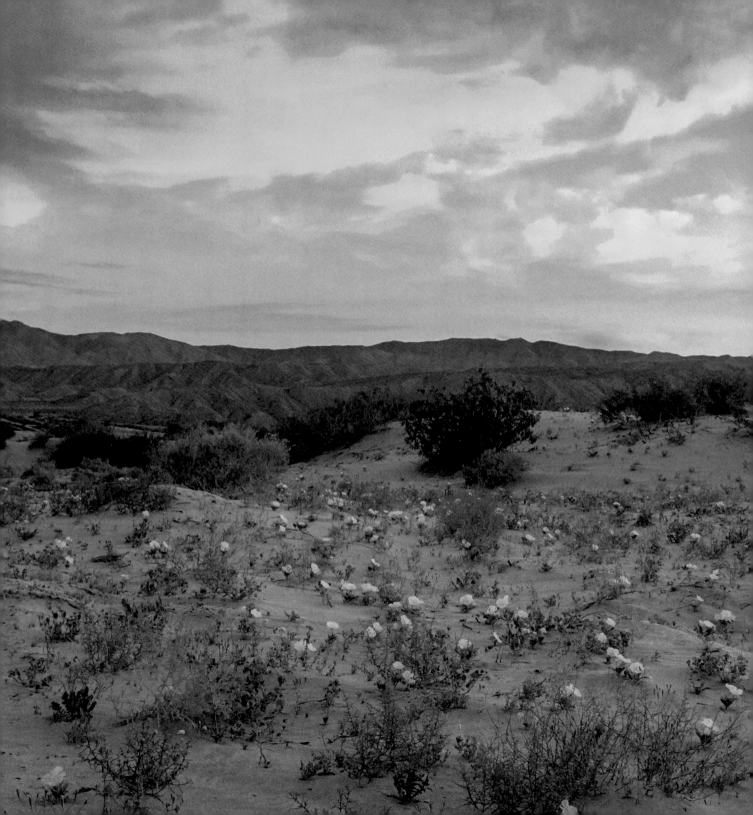

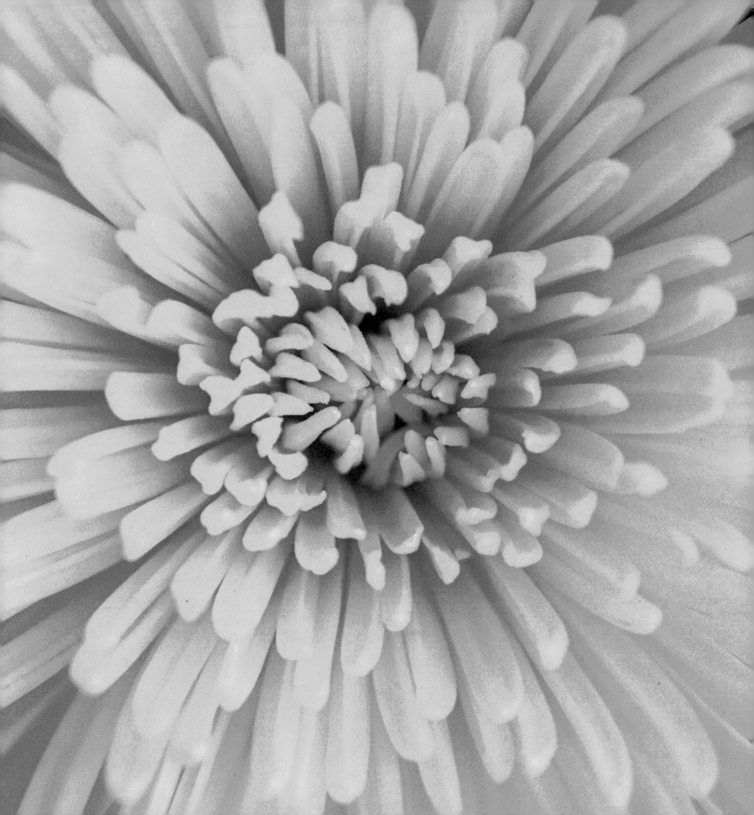

When You Need A Miracle

Now to Him who is able to do far more abundantly beyond all that we ask or think,
according to the power that works within us, to Him be the glory in the church
and in Christ Jesus to all generations forever and ever. Amen.

Ephesians 3:20-21

God is greater than all our wildest imaginings. Even when you think your life is impossible, it is not impossible to God…Nothing is impossible when you know the Lord. These promises about your God can meet your need in any circumstance in your life: fear, sin, suffering, weakness, loss, or change. They are sufficient for all the twists and turns, traumas and devastations of life. Just when you least expect it, God can surprise you with something that never entered your mind, and therefore, you can hope in Him.

Walking with the God Who Cares — A 30-Day Journey ©2007, 2016

Lord, thank You for the hope that You can do a miracle
in a seemingly impossible situation. Amen.

It is not hard, you find, to trust the management of the universe, and of all the outward creation, to the Lord. Can your case then be so much more complex and difficult than these, that you need to be anxious or troubled about His management of you? Away with such unworthy doubtings! Take your stand on the trustworthiness of your God, and see how quickly all difficulties will vanish before a steadfast determination to believe. Trust in the dark, trust in the light, trust at night and trust in the morning, and you will find that the faith that may begin perhaps by a mighty effort, will end, sooner or later, by becoming the easy and natural habit of the soul.

The Christian's Secret Of A Happy Life — Hannah Whitall Smith

Difficulty is the very atmosphere of a miracle—it is a miracle in its first stage. If it is to be a great miracle, the condition is not difficulty but impossibility. Do not balk at difficulty if you believe in God—He deals in miracles.

Streams In The Desert — Mrs. Charles Cowman

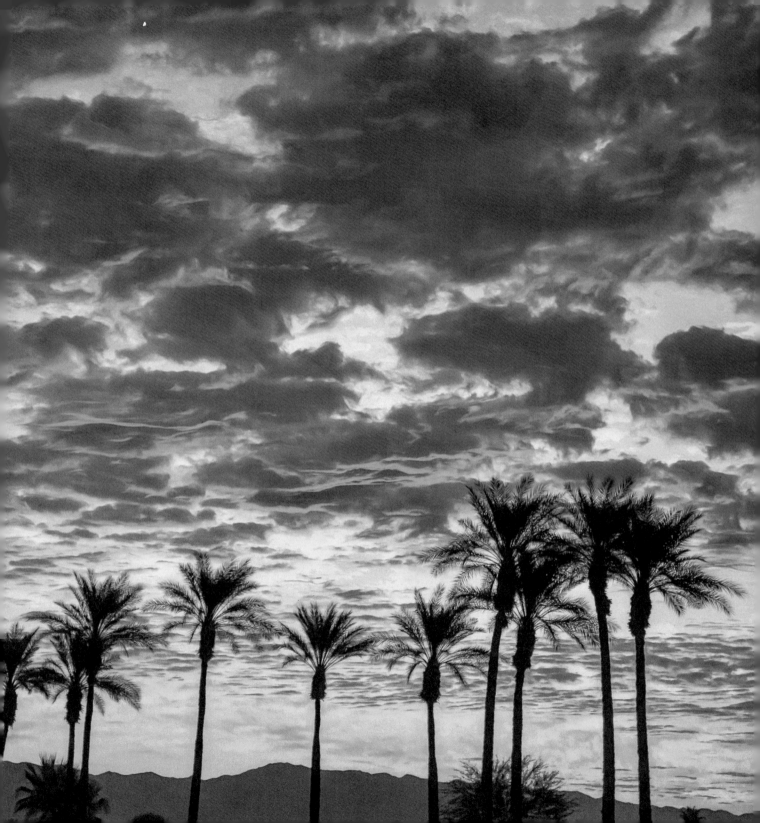

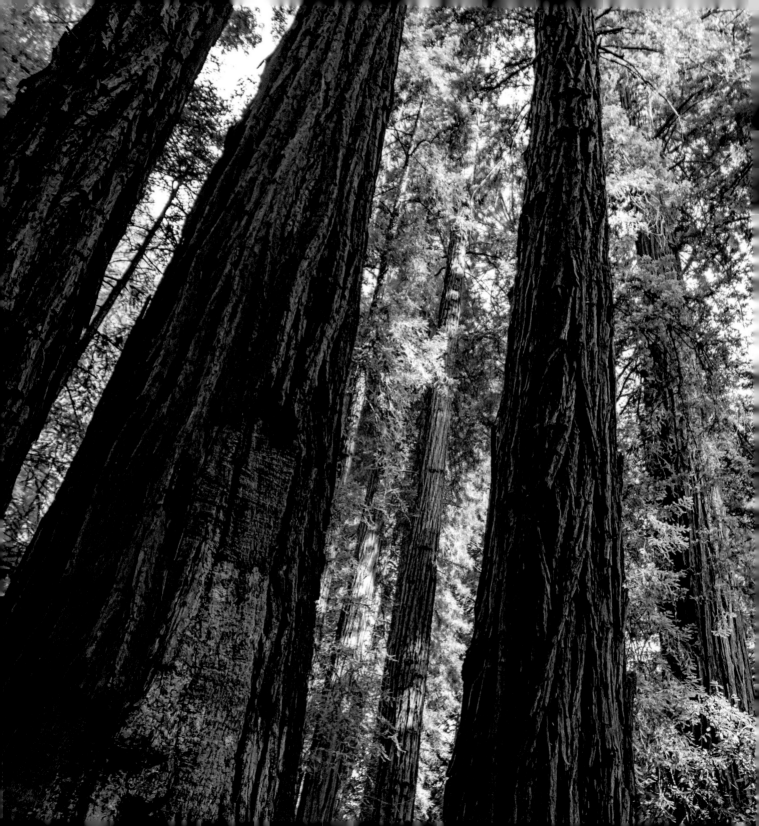

WHEN YOUR LIFE DOES NOT MAKE SENSE

My times are in Your hand;
Deliver me from the hand of my enemies and from those who persecute me.

PSALM 31:15

God holds the events of your life in His hand…The Hebrew word for "times" is *et* and covers a broad spectrum from simple occasions and circumstances to vast opportunities and seasons of your life… But you need to know that tragedy can become triumph because you are in God's hand. Even if you do not know the whys and hows of trauma, tragedy, and suffering, you can find comfort in the mighty hand that is holding you and guiding the course of your life. Knowing you are in His hand takes you beyond the crush of despair to the victory of hope…Life seems impossible at times, but God's hand lifts you up.

WALKING WITH THE GOD WHO CARES — A 30-DAY JOURNEY ©2007, 2016

Lord, I find great comfort and hope today
knowing the truth that I am in Your hand. Amen.

God has been pleased to write some of his promises in sympathetic ink, which can only become visible as it is held close to the fire. You can see the stars in the daytime if you go to the bottom of a deep well, and you can see many a starry promise shining brightly when you are at the bottom of the well of trouble.

Spurgeon's Sermons — Charles Haddon Spurgeon

In seasons of severe trial, the Christian has nothing on earth that he can trust to, and is therefore compelled to cast himself on his God alone. When his vessel is on its beam-ends, and no human deliverance can avail, he must simply and entirely trust himself to the providence and care of God. Happy storm that wrecks a man on such a rock as this! O blessed hurricane that drives the soul to God and God alone! There is no getting at our God sometimes because of the multitude of our friends; but when a man is so poor, so friendless, so helpless that he has nowhere else to turn, he flies into his Father's arms, and is blessedly clasped therein…Be strong and very courageous, and the Lord thy God shall certainly, as surely as He built the heavens and the earth, glorify Himself in thy weakness, and magnify His might in the midst of thy distress.

Morning And Evening — Charles Haddon Spurgeon

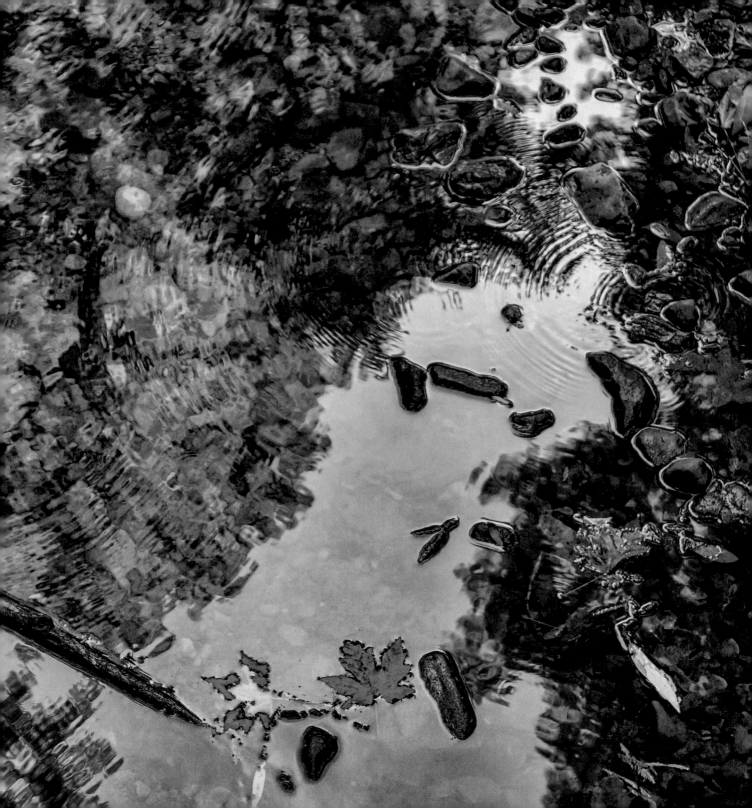

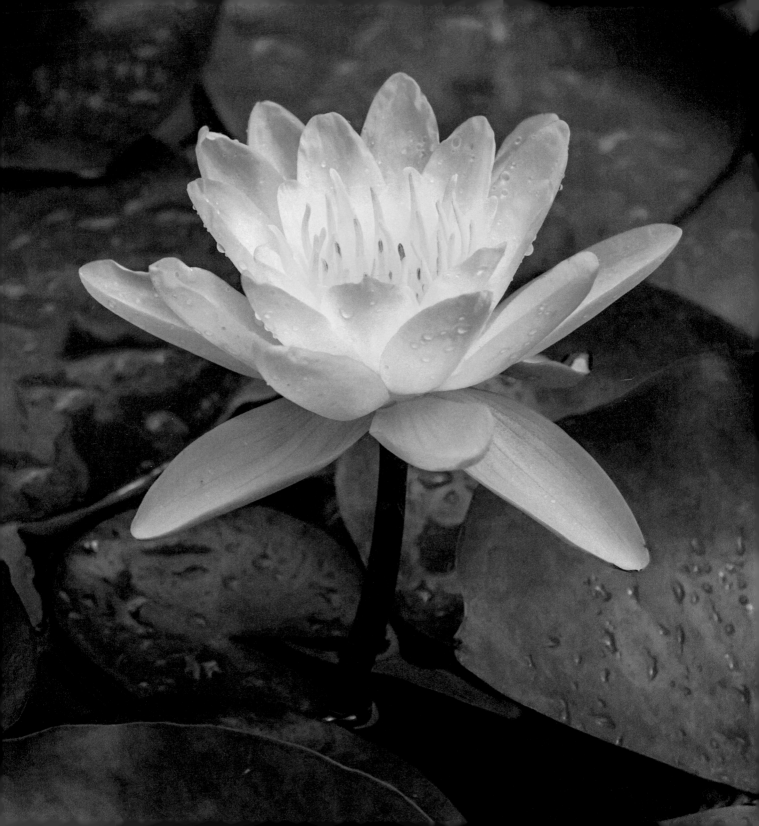

When You Need to Experience God's Power

Though I walk in the midst of trouble, You will revive me; You will stretch forth Your hand against the wrath of my enemies, and Your right hand will save me. The Lord will accomplish what concerns me; Your lovingkindness, O Lord, is everlasting…
Psalm 138:7-8

Revival is receiving from God the restoration and strength that you need in order to walk with Him. He gives you what you need to carry on. It may come in the form of forgiveness of sin, strength in weakness, a change in attitude, love for an enemy, an idea for ministry, or wisdom in a difficult situation. Whenever the Lord works in your heart and in your life, you are experiencing His reviving touch through the power of the Holy Spirit. This is why personal revival must be seen as absolutely necessary to your normal experience with God. It is not something elusive and optional. It is vital.

Revive my Heart — Quiet Times for the Heart ©2003, 2011

Lord, thank You for the hope that You will do whatever is needed in my life to accomplish Your purpose. Amen.

This, then, is the sum of the whole matter. When weary, thirsty souls go to Jesus, He gives them instant relief, by giving them His Holy Spirit; and in that most blessed of all gifts, He Himself glides into the eager nature. He does not strive nor cry; there is no sound as of a rushing storm of wind, no coronet of flame; whilst men are watching at the front door to welcome Him with blare of trumpet, He steals in at the rear, unnoticed; but, in any case, He suddenly comes to His temple, and sits in its inner shrine as a refiner and purifier of the sons of Levi. Jesus Himself is the supply of our spirits, through the Holy Ghost, whom He gives to be within us and with us for ever.

THE GOSPEL OF JOHN — F.B. MEYER

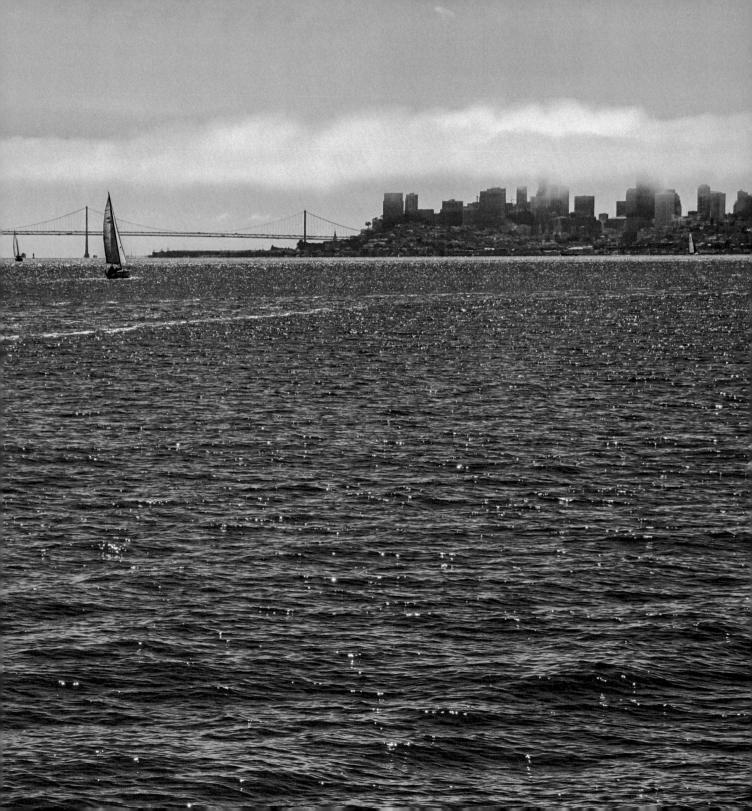

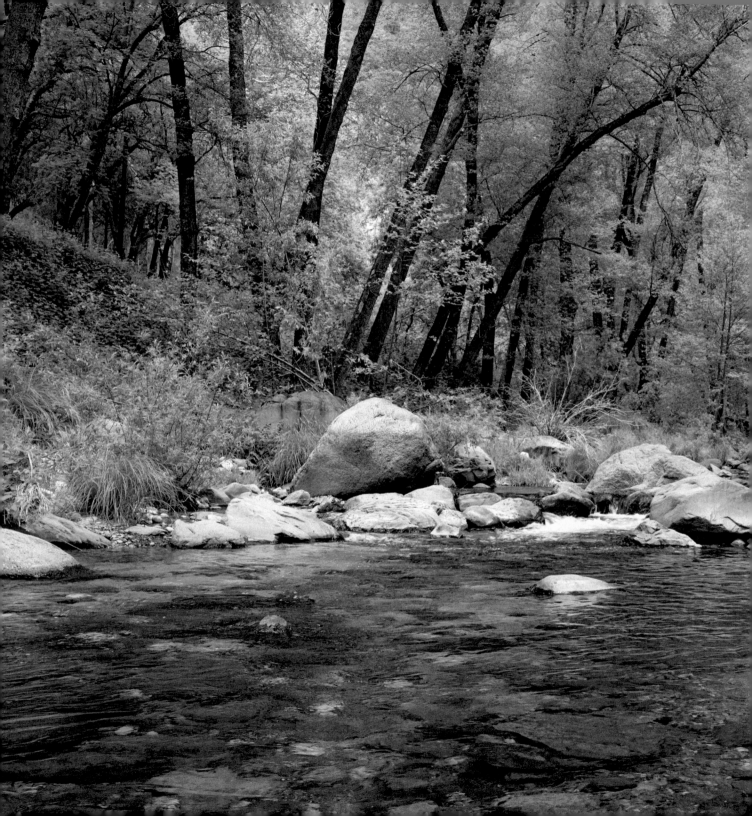

When You Are Losing Hope

This I recall to my mind, therefore I have hope. The Lord's lovingkindnesses indeed never cease, for His compassions never fail. They are new every morning; great is Your faithfulness. "The Lord is my portion," says my soul, "Therefore I have hope in Him."
Lamentations 3:21-24

The promises of God give our hope wings to soar above our trials and circumstances in life…As we immerse and bathe ourselves in what God promises in His Word, we come face-to-face and heart-to-heart with God Himself. When that happens, God Himself is the voice of comfort in our lives. And then He Himself is the One who is our comfort. In the deepest trials of life, we often have no earthly options, and we are left to ourselves and to God. But when He comforts, we are comforted indeed…When He comes alongside you in your suffering and ministers to your hurting heart, you will experience a healing that is incomparable to any other on earth.

Walking with the God Who Cares — A 30-Day Journey ©2007, 2016

Lord, I turn to You for comfort, hope, and healing in my heart. Amen.

When all visible evidences that He is remembering us are withheld, that is best; He wants us to realize that His Word, His promise of remembrance, is more substantial and dependable than any evidence of our senses. When He sends the visible evidence that is well also; we appreciate it all the more after we have trusted Him without it.

Messages For The Morning Watch — C.G. Trumball

When peace like a river attendeth my way,
When sorrows like sea billows roll,
Whatever my lot, Thou hast taught me to say,
It is well, it is well, with my soul.

And Lord, haste the day when my faith shall be sight,
The clouds be rolled back as a scroll,
The trump shall resound, and the Lord shall descend;
Even so, it is well with my soul.

It is well, with my soul.
It is well, it is well, with my soul.

It Is Well With My Soul — Horatio Spafford

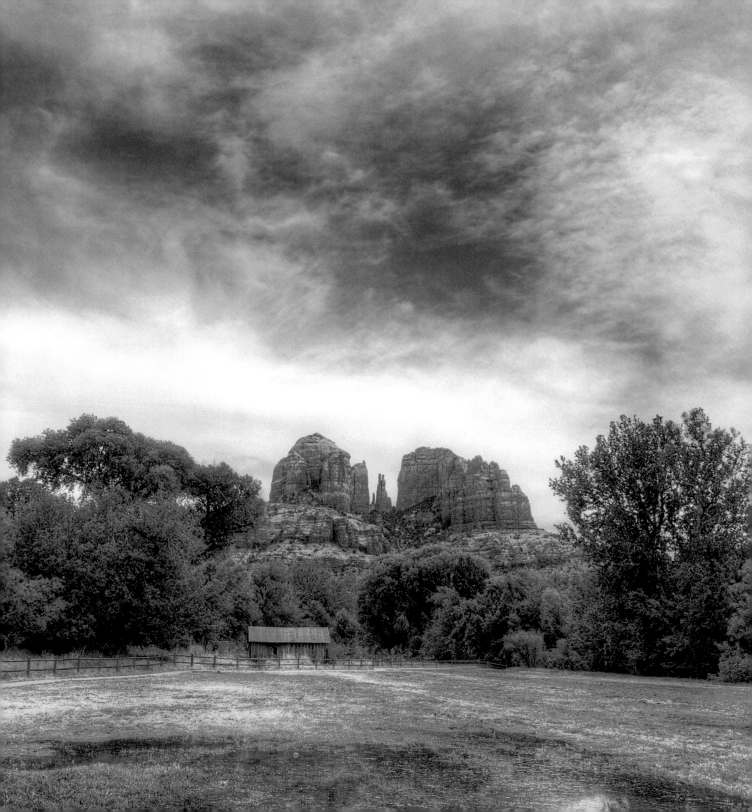

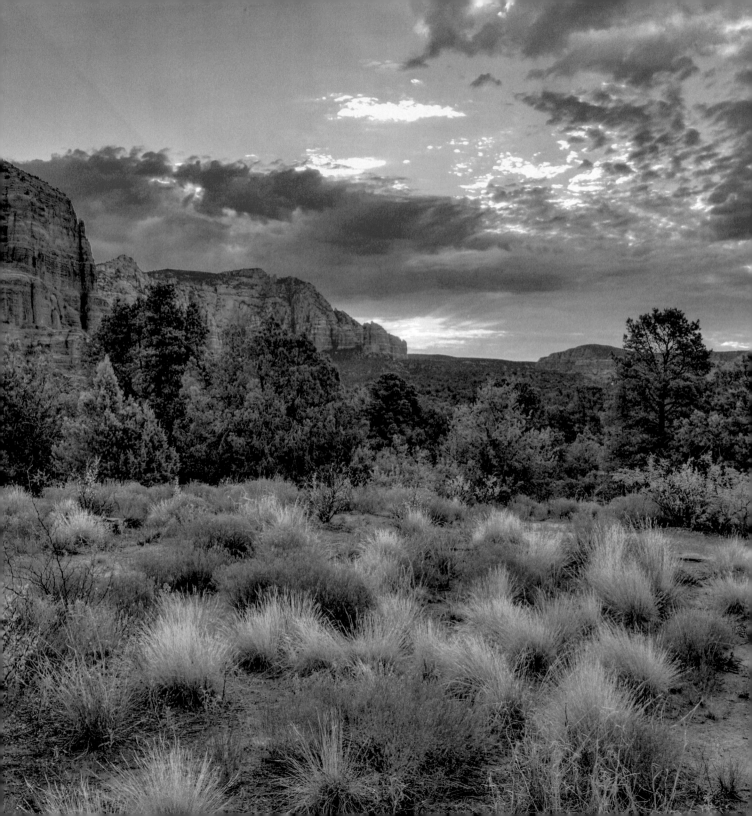

When You Need to Wait

Trust in the Lord and do good…Delight yourself in the Lord, and He will give you the desires of your heart. Commit your way to the Lord, trust also in Him, and He will do it…Rest in the Lord and wait patiently for Him…those who wait for the Lord, they will inherit the land.

Psalm 37:3-5,7,9

What kind of pilgrim is able to wait on the Lord? It is the one with the mature heart, who has been tried and tested, and has gained the ability to endure. It is the pilgrim who is a disciple of Jesus Christ with a reckless, radical abandonment to the will of God. It is the one who is more than a conqueror through Jesus Christ. This is the pilgrim who is able to stand strong. This pilgrim knows his or her own weakness and finds strength in only one place: the Lord.

Pilgrimage of the Heart — Quiet Times for the Heart ©2003, 2016

Lord, knowing You are my refuge gives me great hope. I am waiting on You to strengthen me and to accomplish Your will in my life. Amen.

Sometimes a light surprises the Christian while he sings;
It is the Lord, who rises with healing in His wings;
When comforts are declining, He grants the soul again
A season of clear shining, to cheer it after rain.

In holy contemplation we sweetly then pursue
The theme of God's salvation, and find it ever new;
Set free from present sorrow, we cheerfully can say,
Let the unknown tomorrow bring with it what it may.

It can bring with it nothing but He will bear us through;
Who gives the lilies clothing will clothe His people too;
Beneath the spreading heavens no creature but is fed;
And He who feeds the ravens will give His children bread.

Though vine nor fig tree neither their wonted fruit shall bear,
Though all the field should wither nor flocks nor herds be there;
Yet God the same abiding, His praise shall tune my voice,
For while in Him confiding I cannot but rejoice.

SOMETIMES A LIGHT SURPRISES — WILLIAM COWPER

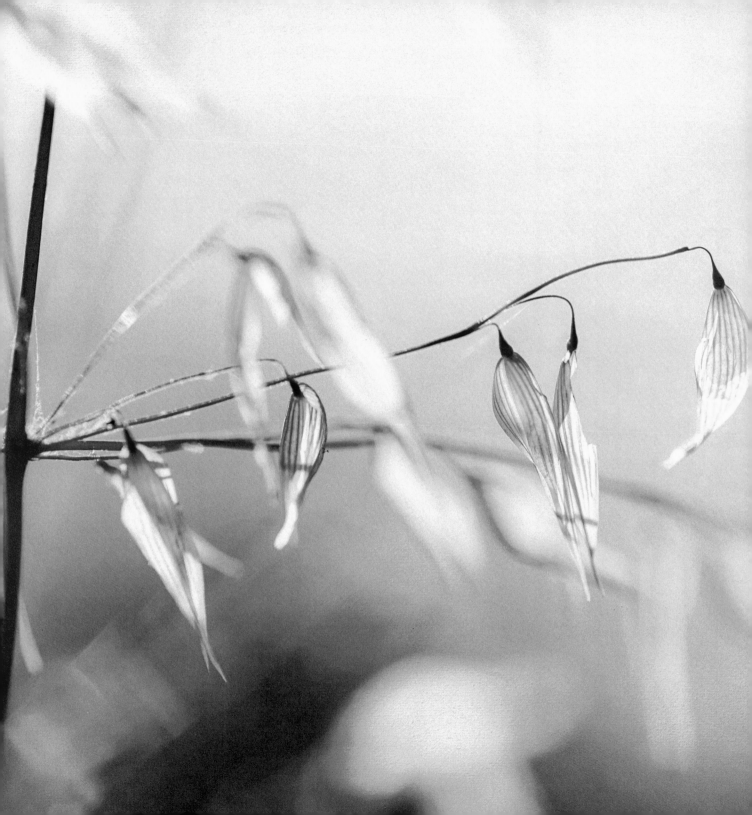

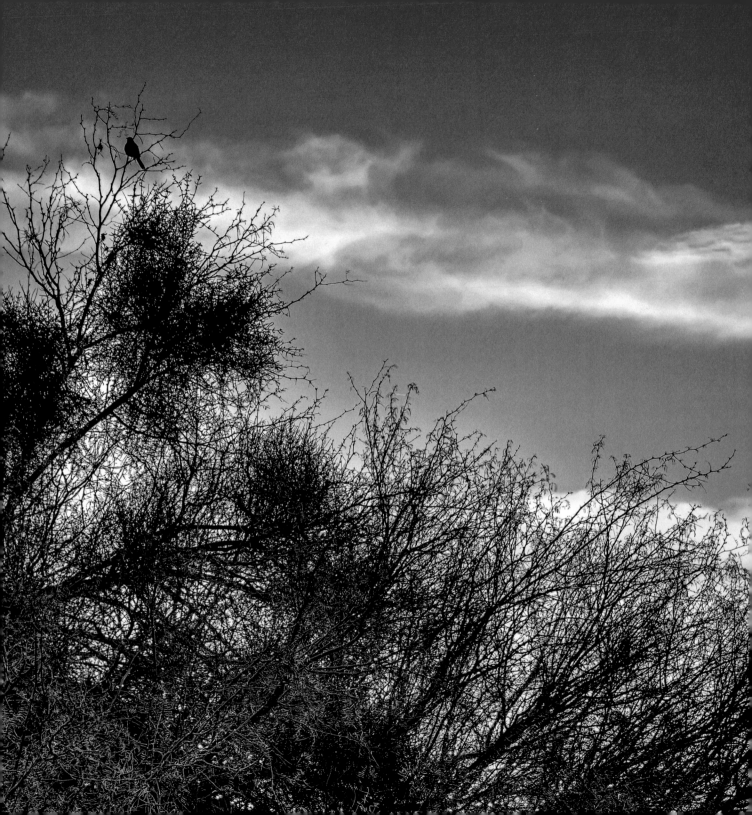

When You Feel Your Life Is Going Nowhere

"For I know the plans that I have for you," declares the Lord,
"plans for welfare and not for calamity to give you a future and a hope."
Jeremiah 29:11

God wants to tell a story to the world through you. It is a story of your relationship with God as He speaks with you in the Bible. God writes the story on your heart first, fashioning and transforming you, making you His man or woman. Your story will unfold through your fellowship as you meet with Him in His Word…You will experience your meaning and purpose in life as you select a Bible, personalize it, live in it, understand what it says, and watch as God uses it to transform your life, reveal Himself to you, and unfold the story of your life.

Knowing and Loving the Bible — A 30-Day Journey ©2007

Lord, thank You for the hope that You are unfolding the story of my life,
giving me true meaning and purpose. Amen.

Nothing pleases our Lord better than to see His promises put into circulation; He loves to see His children bring them up to Him and say, "Lord, do as thou hast said." We glorify God when we plead His promises.

Morning And Evening — Charles Haddon Spurgeon

For when a soul sets out to find God it does not know whither it will come, and by what path it will be led; but those who catch the vision are ready to follow the Lamb whithersoever He goeth, regardless of what that following may involve for them. And it is as they follow, obedient to what they have seen, in the spirit of joyful adventure, that their path becomes clear before them, and they are given the power to fulfil their high calling. They are those who have the courage to break through conventionalities, who care not at all what the world thinks of them, because they are entirely taken up with the tremendous realities of the soul and God.

When God Came — Christian Missionary Society

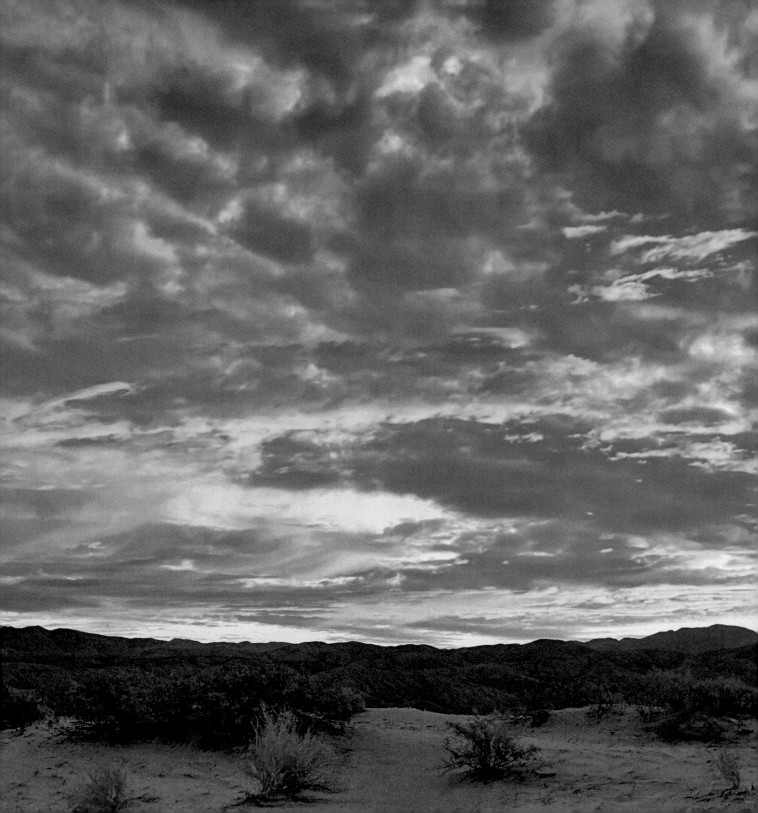

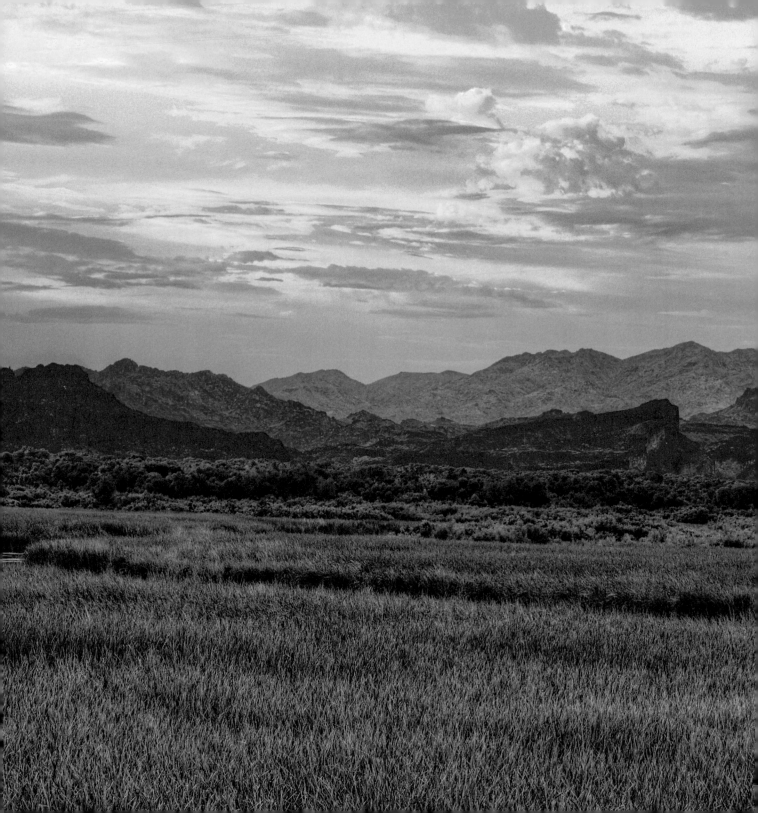

When You Are Feeling Hurt

*And we know that God causes all things to work together for good
to those who love God, to those who are called according to His purpose.*

Romans 8:28

In God's economy, certain truths seem contrary to the natural world. How can any good come from something tumultuous and painful in life? And yet, God promises it over and over again. And if He continues to say it, then we must a some point, begin perhaps dimly at first, then wholeheartedly embrace what He says and apply it to our wounded heart. David's experience is written for all to see. And his firsthand account of what God has done in his time of trouble is here in plain language. David says, "He has made marvelous His lovingkindness to me in a besieged city" (Psalm 31:21). David's trouble brought out new and marvelous expressions of God's love in his life.

A Heart that Hopes in God — A Quiet Time Experience ©2007, 2011

*Lord, thank You for Your promise, and though I cannot see the answer,
I have hope, and I trust You to cause everything in my life to work together for good. Amen.*

God is never in a hurry but spends years with those He expects to greatly use. He never thinks the days of preparation too long or dull. The hardest ingredient in suffering is often time. A short, sharp pain is easily borne, but when a sorrow drags its weary way through long, monotonous years, and day after day returns with the same dull routine of hopeless agony, the heart loses strength, and without the grace of God, is sure to sink into the very sullenness of despair…

We may not see now the outcome of the beautiful plan which God is hiding in the shadow of His hand; it yet may be long concealed; but faith may be sure that He is sitting on the throne, calmly waiting the hour when, with adoring rapture, we shall say, all things have worked together for good…

When we are ready, our deliverance will surely come, and we shall find that we could not have stood in our place of higher service without the very things that were taught us in the ordeal. God is educating us for the future, for higher service and nobler blessings; and if we have the qualities that fit us for a throne, nothing can keep us from it when God's time has come.

Don't steal tomorrow out of God's hands. Give God time to speak to you and reveal His will. He is never too late; learn to wait.

STREAMS IN THE DESERT — MRS. CHARLES COWMAN

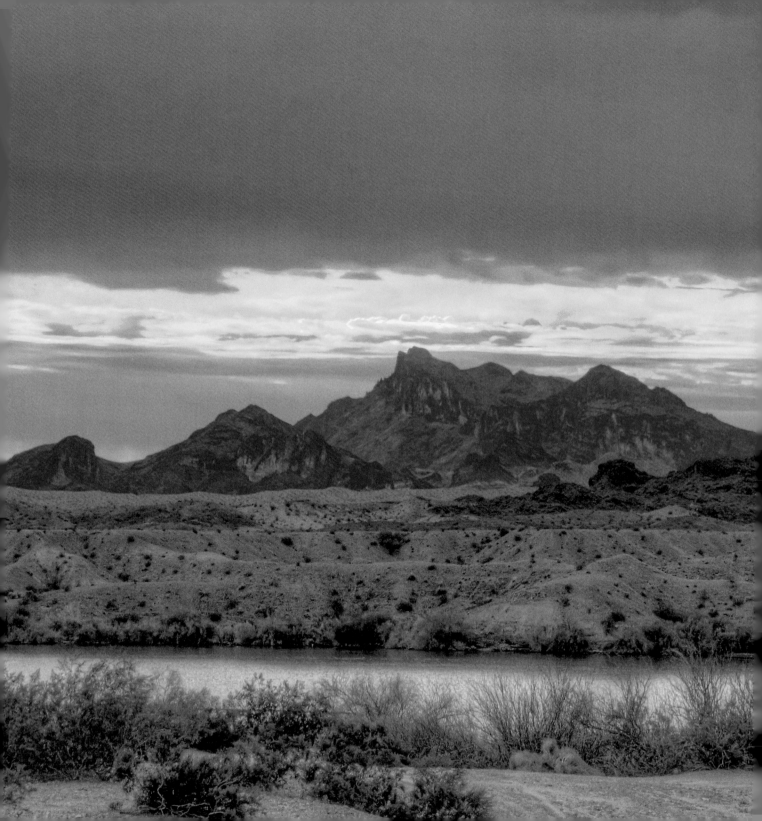

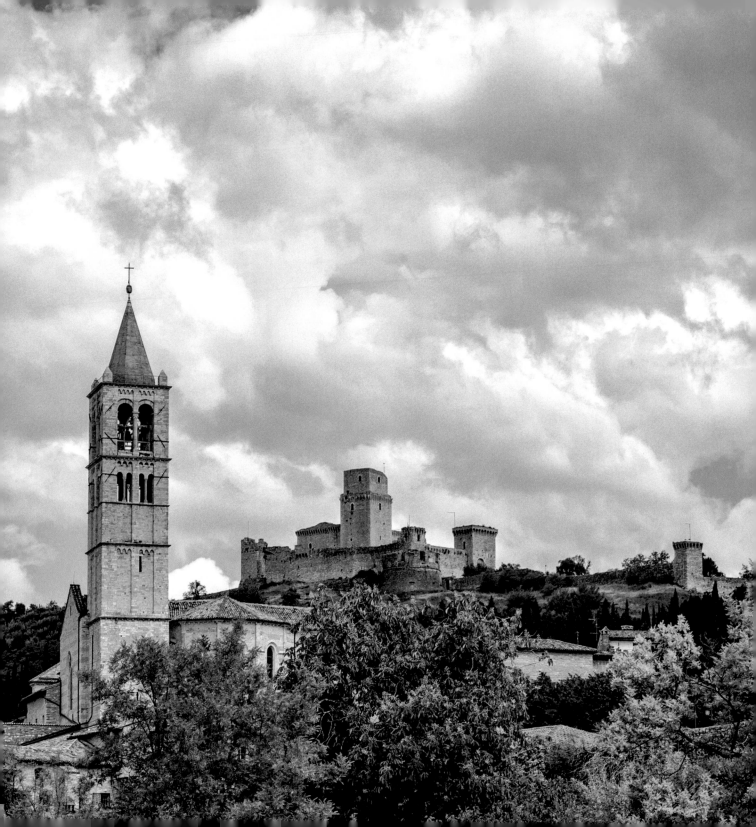

When You Feel Alone

Who will separate us from the love of Christ? Will tribulation, or distress, or persecution, or famine, or nakedness, or peril, or sword?...But in all these things we overwhelmingly conquer through Him who loved us. For I am convinced that neither death, or life, nor angels, nor principalities, nor things present, nor things to come, nor powers, nor height, nor depth, nor any other created thing, will be able to separate us from the love of God, which is in Christ Jesus our Lord.

Romans 8:35,37-39

You are able to make it through the most difficult circumstances in life. Walking on water with your faith means you defy the defeat of the circumstance and literally make it through to the other side. You are enabled and empowered by the very presence and power of Jesus in the midst of your adversity or challenge. You experience real triumph and victory.

Walk on Water Faith — A Quiet Time Experience ©2014

Lord, thank You for Your loving presence, and the amazing hope of Your victory in every circumstance, no matter how difficult. Amen.

My Jesus, I love Thee, I know Thou art mine;
For Thee all the follies of sin I resign;
My gracious Redeemer, my Savior art Thou;
If ever I loved Thee, my Jesus, 'tis now.

I love Thee because Thou hast first loved me,
And purchased my pardon on Calvary's tree;
I love Thee for wearing the thorns on Thy brow;
If ever I loved Thee, my Jesus, 'tis now.

I'll love Thee in life, I will love Thee in death,
And praise Thee as long as Thou lendest me breath;
And say when the death-dew lies cold on my brow;
If ever I loved Thee, my Jesus, 'tis now.

In mansions of glory and endless delight,
I'll ever adore Thee in heaven so bright;
I'll sing with the glittering crown on my brow;
If ever I loved Thee, my Jesus, 'tis now.

My Jesus, I Love Thee — William R. Featherstone

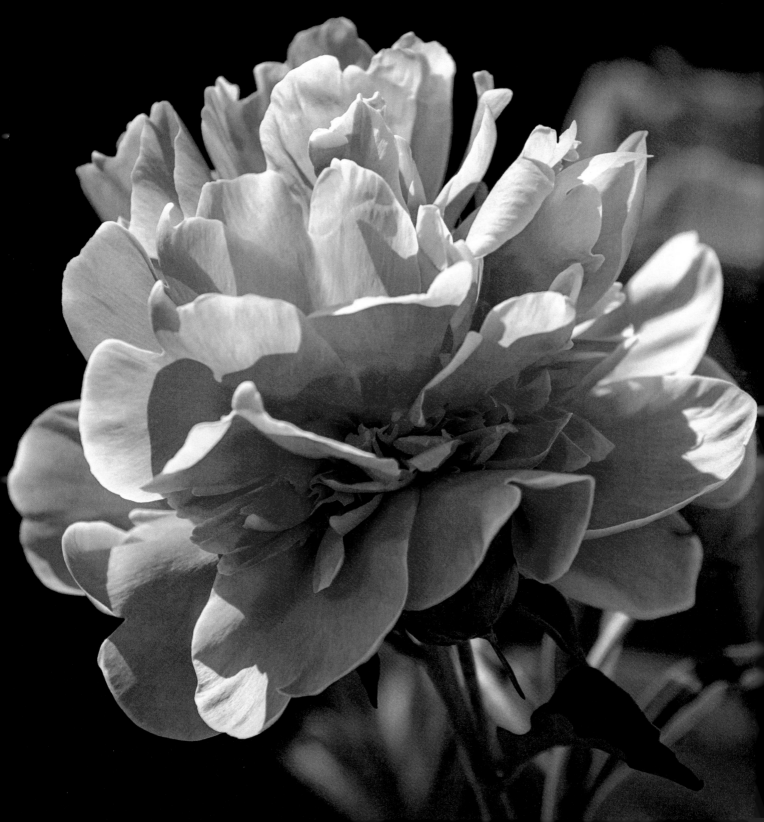

When You Need Strength

Do not fear, for I am with you; do not anxiously look about you, for I am your God.
I will strengthen you, surely I will help you, surely I will uphold you with My righteous right hand.

Isaiah 41:10

The Holy Spirit will give you strength in trials and difficult circumstances. When you experience trials and tribulations, you will be tempted to rely on your own minuscule strength. But God wants you to rely on His strength, from the Holy Spirit in you, in the very heat of the trial…You need to know that God is able, and He has every resource and capability to handle whatever comes your way. The secret to victory in difficulties will always be finding your strength in the Lord and not in yourself regardless of how strong you think you are.

Set My Heart on Fire — A 30-Day Journey ©2008

Lord, thank You that You are always with me, and You will help me and give
me strength. Your presence brings hope to me today. Amen.

The things that hedge us in, the things that handicap us, the tests that we go through and the temptations that assail us, are all divinely appointed wood cutters used by God to hew out a path for our preaching of the gospel.

It may be that our fondest hopes are not realized. We are in difficult circumstances. Illness may be our lot. Yet if we are in the center of God's will, all these are contributing to the progress of the gospel. They draw us closer to the Lord so that the testimony of our lives will count more for God, and thus we become more efficient in proclaiming the gospel.

Thank God for the handicaps and the testings. They are blessings in disguise. When we have limitations imposed upon us we do our best work for the Lord, for then we are most dependent on Him.

Wuest's Word Studies In The Greek New Testament — Kenneth Wuest

Send me, gracious Lord, the Comforter.
May He fill my nature as the rain fills the pools;
and may the parched ground of my heart become as a garden.
Instead of the thorn may there come up a fig tree,
and instead of the briar, the myrtle.

Daily Prayers — F.B. Meyer

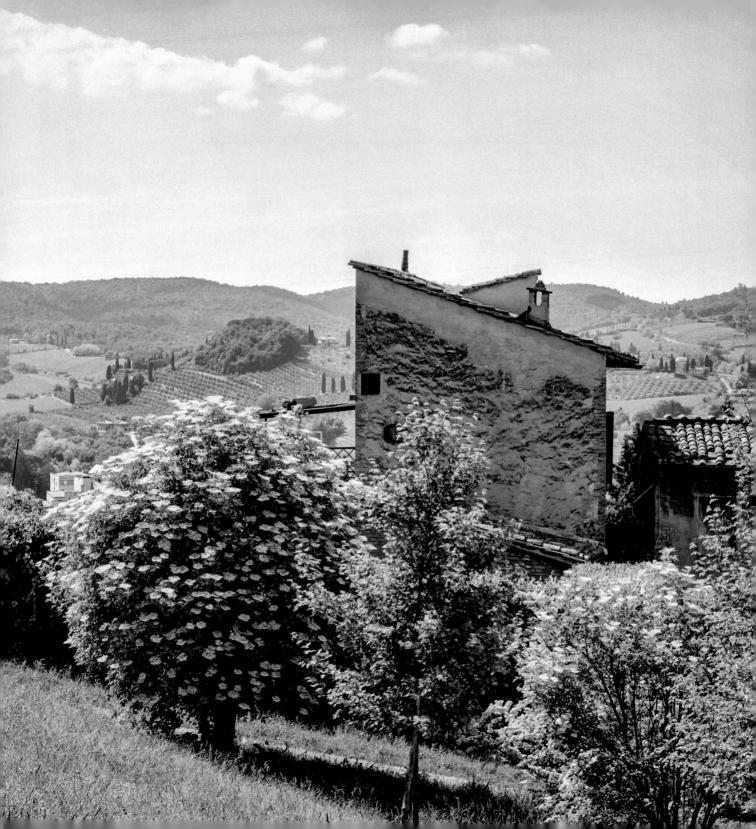

When You Feel Forgotten

Can a woman forget her nursing child and have no compassion on the son of her womb?
Even these may forget, but I will not forget you. Behold, I have inscribed you
on the palms of My hands; Your walls are continually before Me.

Isaiah 49:15-16

There are times in our lives when we feel forgotten. Perhaps we have wandered away from the Lord. Or we are experiencing a trial that is seemingly impossible with apparently no obvious answer. And we feel alone in the storm...The truth is that God never forgets us. No, not ever. But the fact is, sometimes you may feel forgotten. And so, in those times, you desperately need the promises of God to fuel your faith.

Walk on Water Faith — A Quiet Time Experience ©2014

Lord, I know today that You never forget me.
Thank You for that hope, and the knowledge
that I am inscribed on the palms of Your hands. Amen.

See the star that's brightly glowing, just before the dawning,
Herald of the coming day, of light and life and warming.
I have seen the light of Jesus, in my soul's confusion.
He was there to guide me home, and bring me to the morning.

I have heard the voice of Jesus, calling me to follow.
On the path that He has trod, towards that bright tomorrow.
I have felt the hand of Jesus, resting on my shoulder.
Lifting, when my footsteps failed, or when the road was harder.

I have known the love of Jesus, comforting and warming.
Strengthening my certitude, that He is my Redeemer.
His, the light that shines undimming, beacon in life's journey.
He is the bright morning star, my Saviour and my Master.

The Bright Morning Star — M.A. Bloomfield

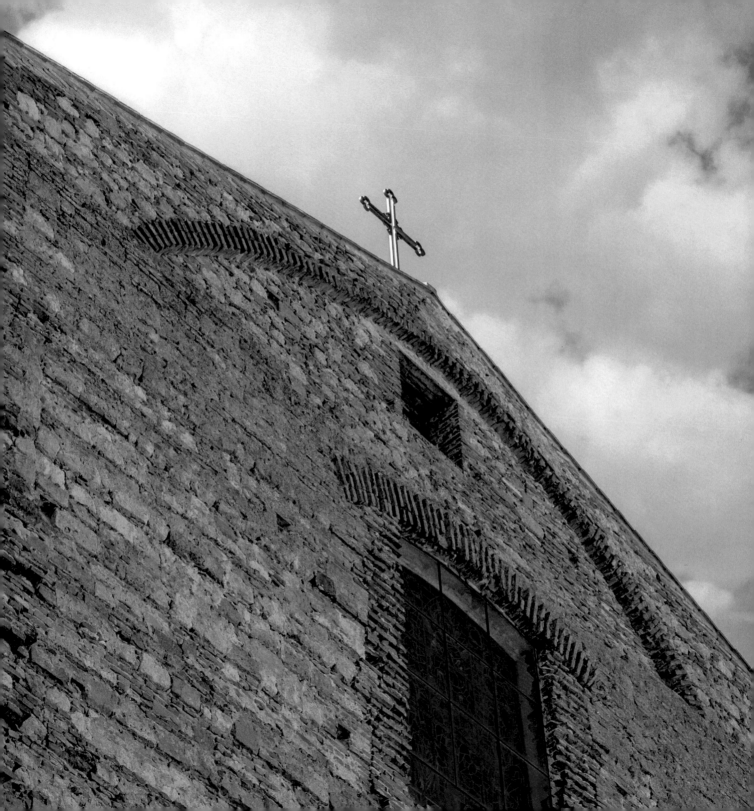

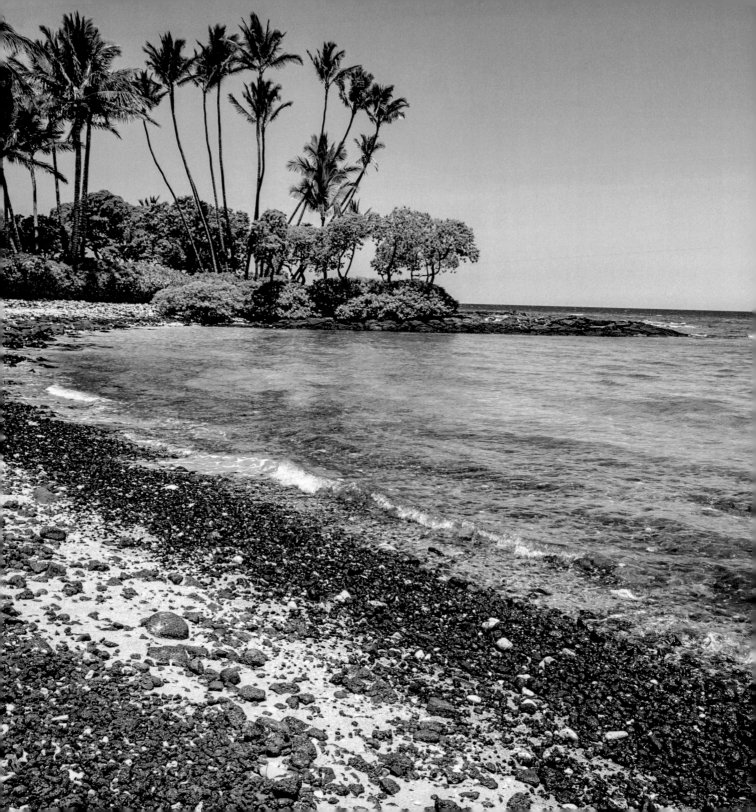

When You Need the Grace of God

For we do not have a high priest who cannot sympathize with our weaknesses, but One who has been tempted in all things as we are, yet without sin. Therefore let us draw near with confidence to the throne of grace, so that we may receive mercy and find grace to help in time of need.

Hebrews 4:15-16

God invites us, His children, into His throne room…Because of grace, when we enter the throne room, we find the favor and smile of God. And there is one who understands our suffering, our need, our desire, and enters into our dilemma with us, whatever our circumstance may be…God is telling us to never hesitate to storm the throne of grace and draw near to Him. The door is always open…Our bold prayer is the means of appropriating and taking possession of all the gracious gifts that are ours in Jesus Christ. God's bountiful grace gives and gives and gives.

A Woman's Walk in Grace — A Devotional Journey ©2010

Lord, I come to You in Your throne room and ask for Your grace in my time of need. The promise of grace brings hope to my heart. Amen.

Wonderful grace of Jesus,
Greater than all my sin;
How shall my tongue describe it,
Where shall its praise begin?
Taking away my burden,
Setting my spirit free;
For the wonderful grace of Jesus reaches me.

Wonderful the matchless grace of Jesus,
Deeper than the mighty rolling sea;
Higher than the mountain, sparkling like a fountain,
All-sufficient grace for even me!
Broader than the scope of my transgressions,
Greater far than all my sin and shame;
Oh, magnify the precious Name of Jesus,
Praise His Name!

Wonderful Grace Of Jesus — Haldor Lillenas

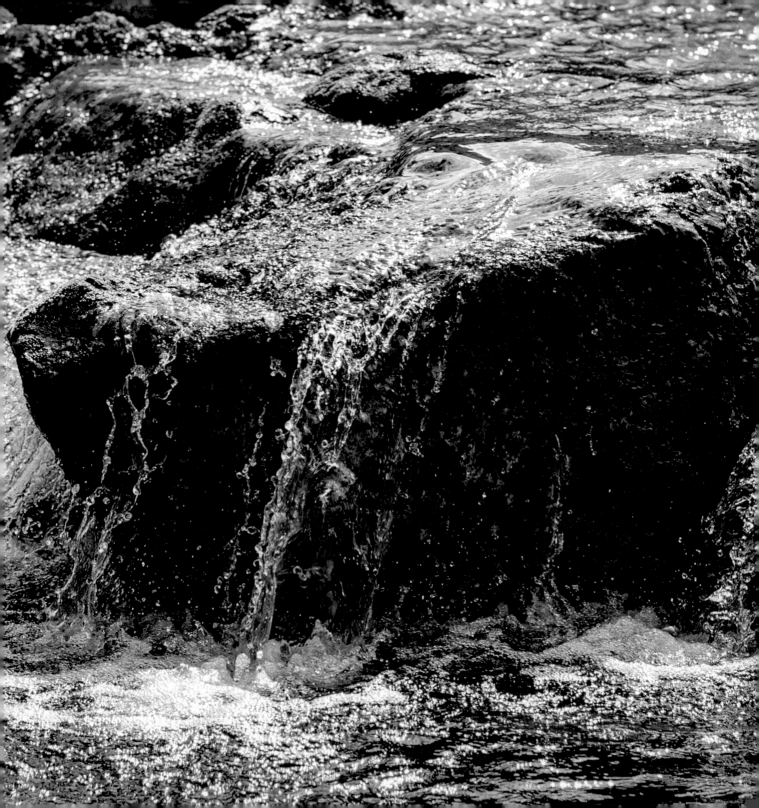

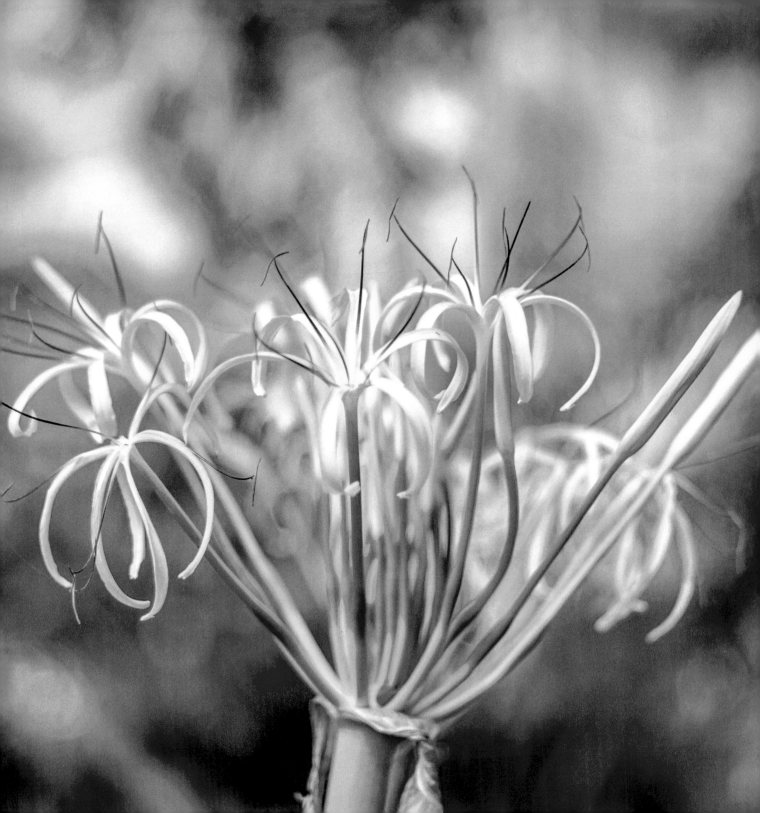

When You Are Suffering

*After you have suffered for a little while, the God of all grace, who called you
to His eternal glory in Christ, will Himself perfect, confirm, strengthen and establish you.*
1 Peter 5:10

God is the God of all grace. He wants to shower you with every grace-filled gift you need to grow—His provision for your needs, His perspective for your circumstances, and His presence for your journey from time to eternity. And so the most important aspect of grace is learning to receive all the gifts God's grace-filled heart gives you…Grace washes away our guilt and shame and gives us forgiveness and eternal life. Eventually, God's grace opens our eyes to our future and a blessed hope. Most importantly, we experience God's plan and purpose in our lives…

A Woman's Walk in Grace — A Devotional Journey ©2010

*Lord, I look to You today, the God of all grace, for grace to carry me
through this difficult time and experience the wondrous hope
of all the gifts You have for me. Amen.*

God hath not promised
Skies always blue,
Flower-strewn pathways
All our lives through;
God hath not promised
Sun without rain,
Joy without sorrow,
Peace without pain.

But God hath promised
Strength for the day,
Rest for the labor,
Light for the way,
Grace for the trials,
Help from above,
Unfailing sympathy,
Undying love.

What God Hath Promised — Annie Johnson Flint

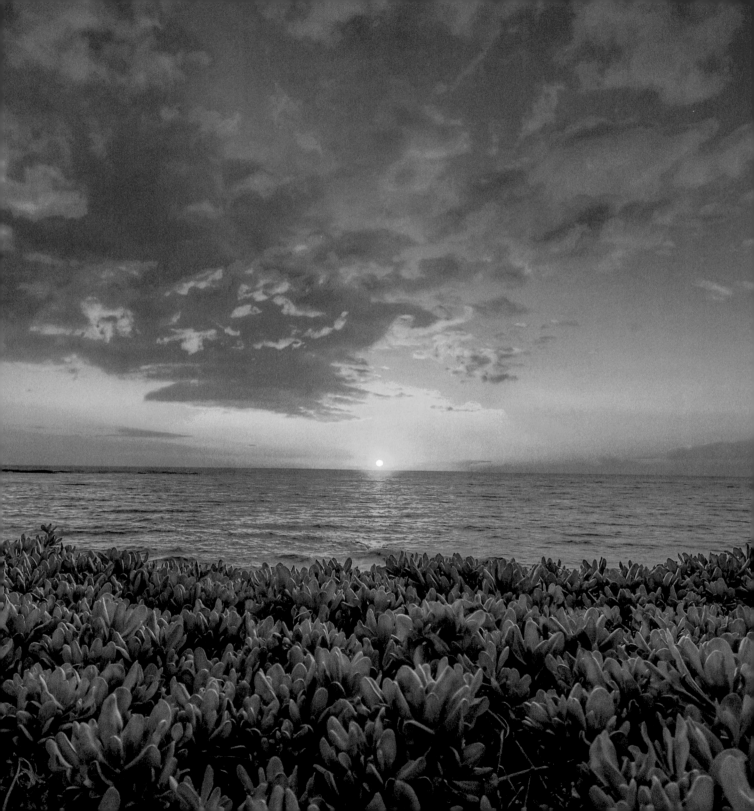

When You Suffer Persecution

Beloved, do not be surprised at the fiery ordeal among you, which comes upon you for your testing,
as though some strange thing were happening to you…If you are reviled for the name of Christ,
you are blessed, because the Spirit of glory and of God rests on you.

1 Peter 4:12,14

One thing you must know. Your response to suffering may be your greatest work according to heaven. That is how it is in the economy of God…Your claim to fame in eternity may be your faith victory in one circumstance. Such was true for Job. It was also true for Jesus. The name that Jesus is known by in heaven is Lamb of God. The focus is on His sacrifice for our sins. Think about the ramifications of this in your own life. It means that no suffering is wasted.

A Heart that Dances — Quiet Times for the Heart ©2003

Lord, keep me strong in the fiery trial and give me faith and hope
to look beyond the present all the way to eternity. Amen.

God moves in a mysterious way, His wonders to perform;
He plants His footsteps in the sea, and rides upon the storm.

Light Shining Out Of Darkness — William Cowper

My goal is God Himself, not joy, nor peace,
Nor even blessing, but Himself, my God;
'Tis His to lead me there, not mine, but His—
At any cost, dear Lord, by any road!
So faith bounds forward to its goal in God,
And love can trust her Lord to lead her there;
Upheld by Him, my soul is following hard
Till God hath full fulfilled my deepest prayer.
No matter if the way be sometimes dark,
No matter though the cost be oft-times great,
He knoweth how I best shall reach the mark,
The way that leads to Him must needs be straight.
One thing I know, I cannot say Him nay;
One thing I do, I press towards my Lord;
My God my glory here, from day to day,
And in the glory there my Great Reward.

My Goal Is God Himself — Frances Brook

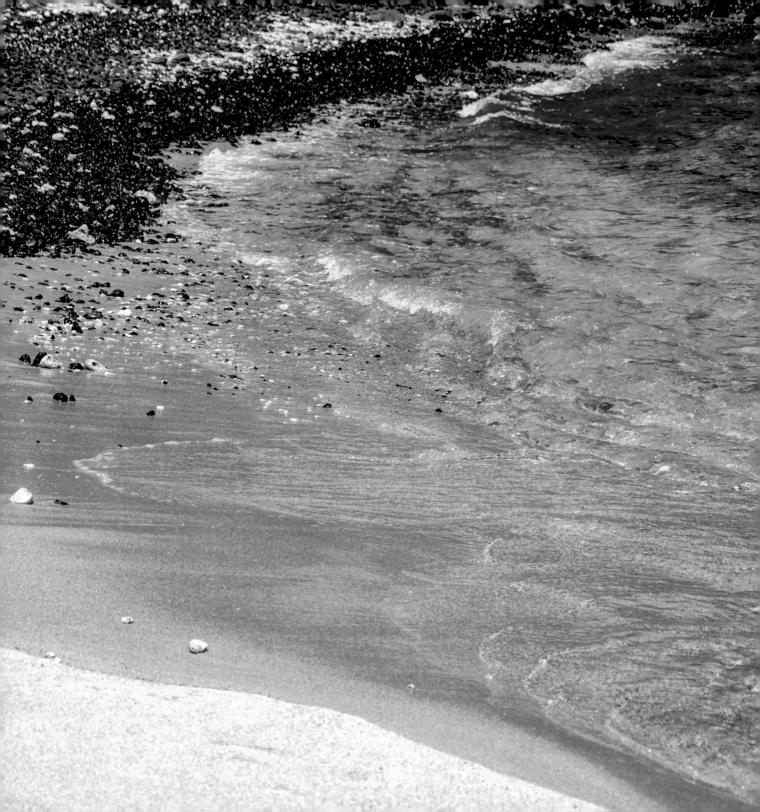

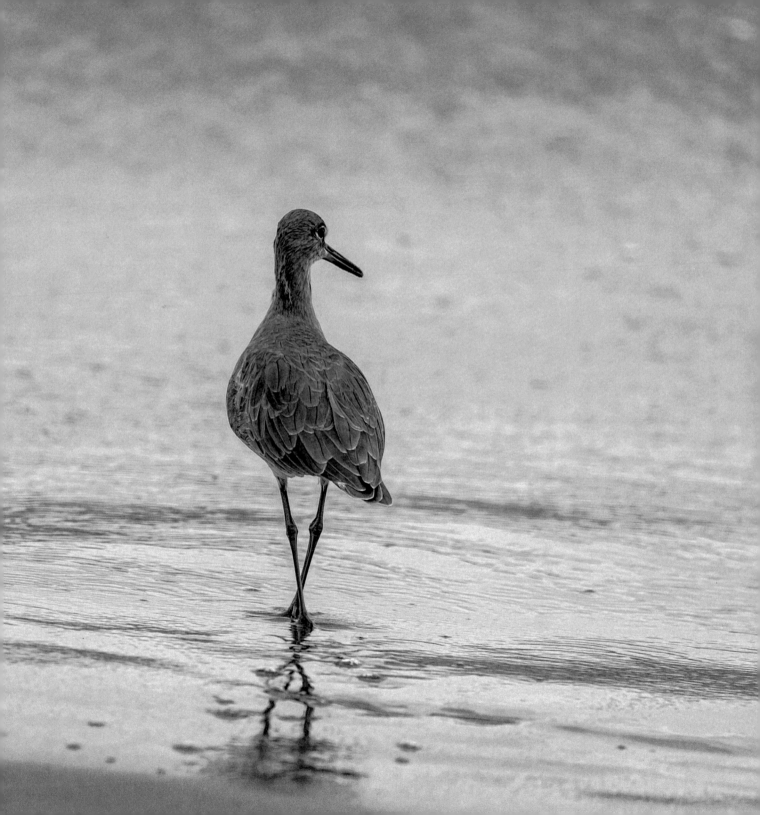

WHEN YOU HAVE A NEED

And my God will supply all your needs
according to His riches in glory in Christ Jesus.
PHILIPPIANS 4:19

God's promise of provision gives you hope when you are in need. God is your provider and will give you what you need when you need it. His promise to "supply" your needs means He will give to you abundantly and liberally…Sometimes God will say no to something good in order to give you the very best. He is giving out of His riches, so He never lacks supply and will generously pour out His blessings on you. Take all your needs to Him today and watch to see what He will do. He will supply your needs. He promises.

myPhotoWalk—Quiet Time Moments — Devotional Photography ©2016

Lord, thank You for promising to supply all my needs.
I look to You with great hope for every good thing in Your perfect timing. Amen.

My shepherd will supply my need,
Jehovah is his name;
In pastures fresh he makes me feed,
Beside the living stream.
He brings my wand'ring spirit back
When I forsake his ways;
And leads me, for his mercy's sake,
In paths of truth and grace.
When I walk through the shades of death,
Thy presence is my stay;
A word of thy supporting breath
Drives all my fears away.
Thy hand, in sight of all my foes,
Doth still my table spread,
My cup with blessings overflows,
Thine oil anoints my head.
The sure provisions of my God
Attend me all my days:
O may thy house be mine abode,
And all my work be praise!
There would I find a settled rest,
While others go and come;
No more a stranger or a guest,
But like a child at home.

THE PSALMS OF DAVID — ISAAC WATTS

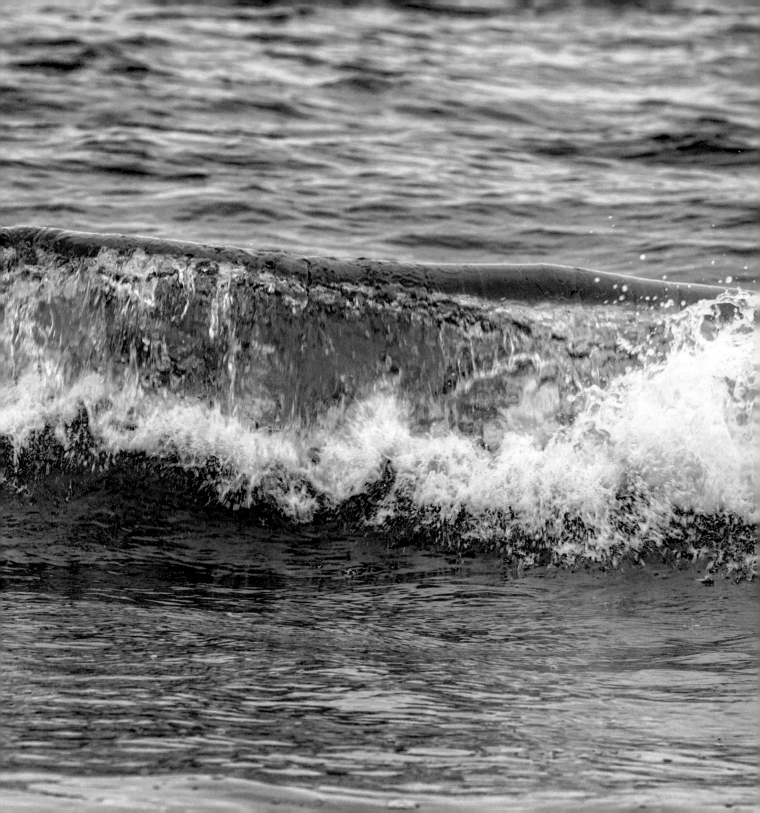

When You Need Strength for the Impossible

I can do all things through Him who strengthens me.

Philippians 4:13

The promise of strength for "all things" includes all things: forgiveness for enemies, endurance for pain, and faith for impossible obstacles. Whatever you need, God's strength is enough. Not only is His strength enough, it is more than enough. Paul says, "Now to Him who is able to do far more abundantly beyond all that we ask or think, according to the power that is at work within us" (Ephesians 3:20). Think for a moment what it means to have resources more than equal to your greatest need, whatever your need may be. Just imagine the strength of the Holy Spirit—the infinite power of God at work in your life.

Run Before the Wind — A Quiet Time Experience ©2008, 2012

Lord, I turn to You now for the strength in all the impossible circumstances in my life.
I have the hope that You are enough for anything I face today. Amen.

The Spirit-filled Christian no longer thinks of Christ as his helper to do some kind of Christian task. Rather, he recognizes that Jesus Christ does the work through the Christian. Jesus does not want us to work for Him; He wants us to let Him do His work in and through us.

THE HOLY SPIRIT—THE KEY TO SUPERNATURAL LIVING — BILL BRIGHT

We say we are weak;
but that is just the reason why God chooses us,
that He in us may be strong.

KESWICK'S AUTHENTIC VOICE — REVEREND HUBERT BROOKE

Have we not known men whose lives have not given out any entrancing music in the day of a calm prosperity, but who, when the tempest drove against them have astonished their fellows by the power and strength of their music?

STREAMS IN THE DESERT — MRS. CHARLES COWMAN

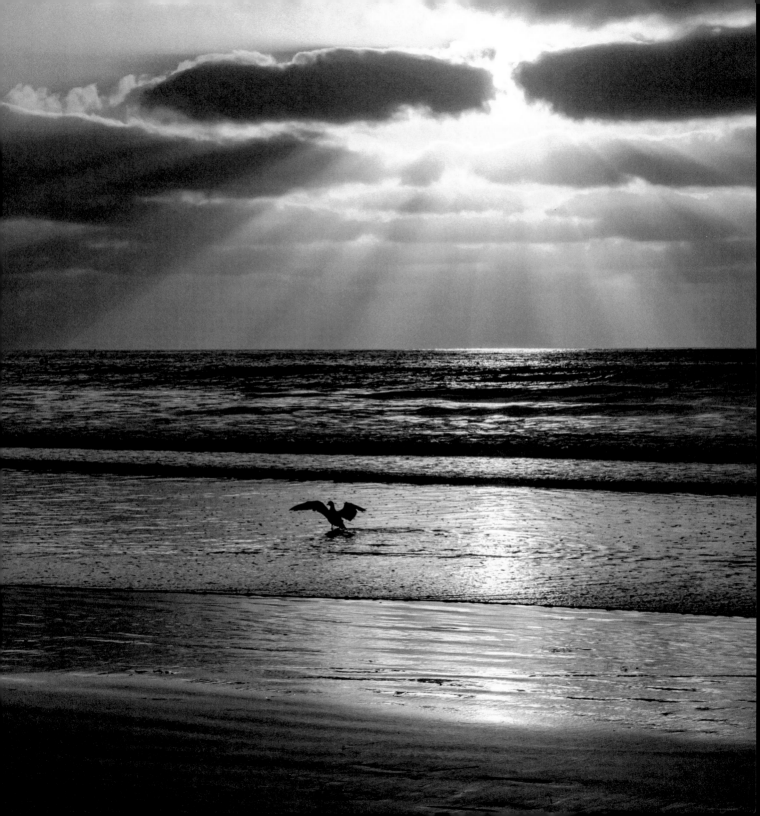

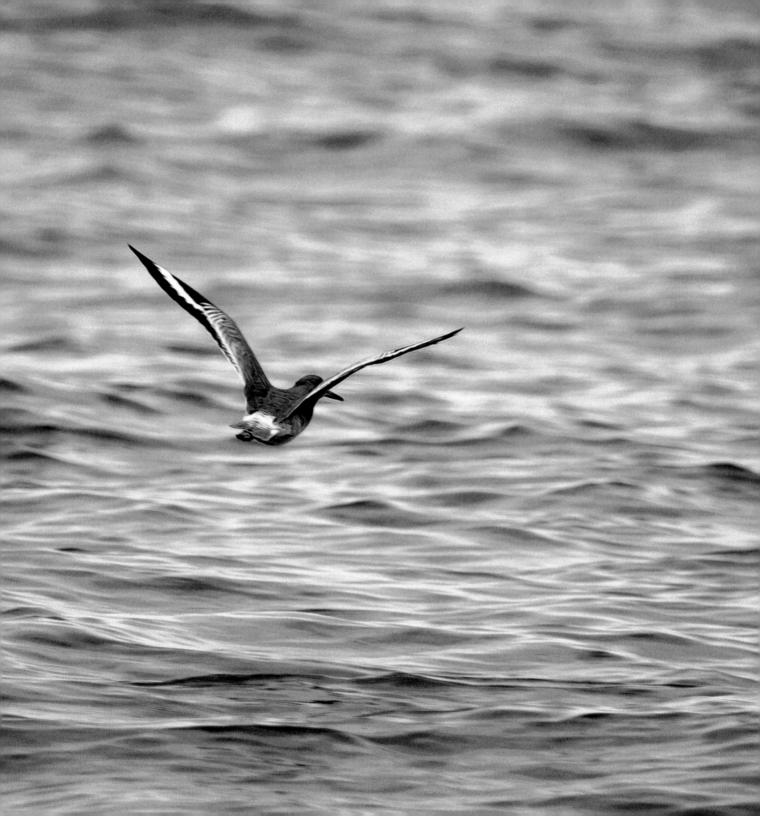

When You Can't Let Go of Guilt

Therefore there is now no condemnation for those who are in Christ Jesus.
For the law of the Spirit of life in Christ Jesus has set you free from the law of sin and of death.
Romans 8:1-2

Once you have entered into a relationship with Christ, you are no longer who you were. Christ lives in you through the indwelling Holy Spirit. And He is at work in you, transforming your heart, character, and life so they reflect His new life in you. He does in you what you could never do for yourself. You become the person God wants you to be. He changes you, growing you from the inside out. A new person (Jesus) and power (the Holy Spirit) live in you, and you can live supernaturally, doing what you could never do before and becoming who you could never be in your own strength. He sets you free...You are forgiven and set free to love and serve and live with Him forever.

A Woman's Walk in Grace — A Devotional Journey ©2010

Lord, thank You for forgiving my sin and setting me free forever. Freedom
without condemnation brings me such hope today. Amen.

Have thine own way, Lord! Have thine own way!
Thou art the potter, I am the clay.
Mold me and make me after thy will,
while I am waiting, yielded and still.

Have thine own way, Lord! Have thine own way!
Search me and try me, Savior today!
Wash me just now, Lord, wash me just now,
as in thy presence humbly I bow.

Have thine own way, Lord! Have thine own way!
Wounded and weary, help me I pray!
Power, all power, surely is thine!
Touch me and heal me, Savior divine!

Have thine own way, Lord! Have thine own way!
Hold o'er my being absolute sway.
Fill with thy Spirit till all shall see
Christ only, always, living in me!

Have Thine Own Way — Adelaide A. Pollard

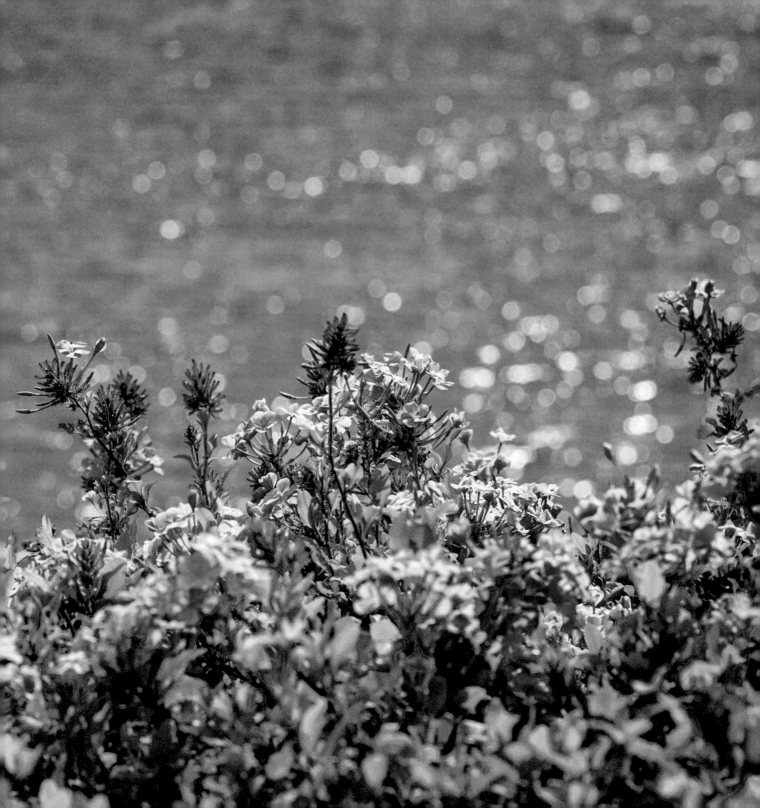

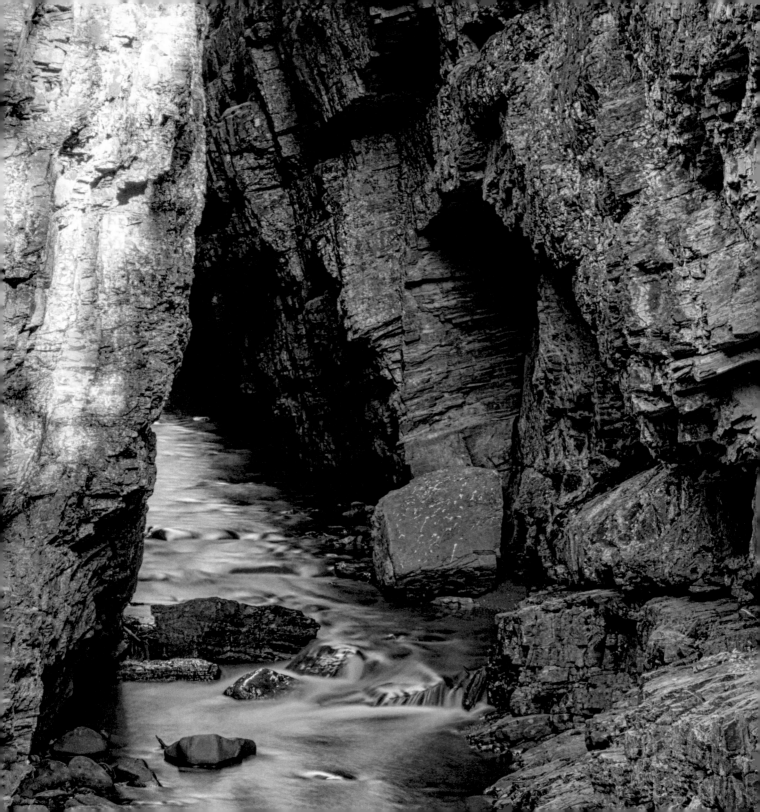

When You Are Losing Heart

Therefore we do not lose heart…our inner man is being renewed day by day. For momentary, light affliction is producing for us an eternal weight of glory far beyond all comparison, while we look…at the things which are not seen; for the…things which are not seen are eternal.

2 Corinthians 4:16-18

Those with the deepest despairs can know the greatest hopes…The hope that God wants to give you is based on the promises in His Word and will serve as the anchor of your soul. Every time God gives you a promise in the Word, there is one more tether of your soul to the firm foundation of the eternal, and it expands the ground of your hope. It is God's Word that allows you to smile even when your life is falling apart. There is so much you can know is true because of what God says. And what God says will give you a great hope.

A Heart to See Forever — Quiet Times for the Heart ©2003, 2011

Lord, I look to You for Your eternal perspective found in Your Word and for hope of the eternal, unseen truths found in Your promises. Amen.

He giveth more grace when the burdens grow greater,
He sendeth more strength when the labors increase;
To added affliction He addeth His mercy,
To multiplied trials, His multiplied peace.

When we have exhausted our store of endurance,
When our strength has failed ere the day is half done,
When we reach the end of our hoarded resources,
Our Father's full giving is only begun.

His love has no limit, His grace has no measure,
His power no boundary known unto men;
For out of His infinite riches in Jesus
He giveth and giveth and giveth again.

HE GIVETH MORE — ANNIE JOHNSON FLINT

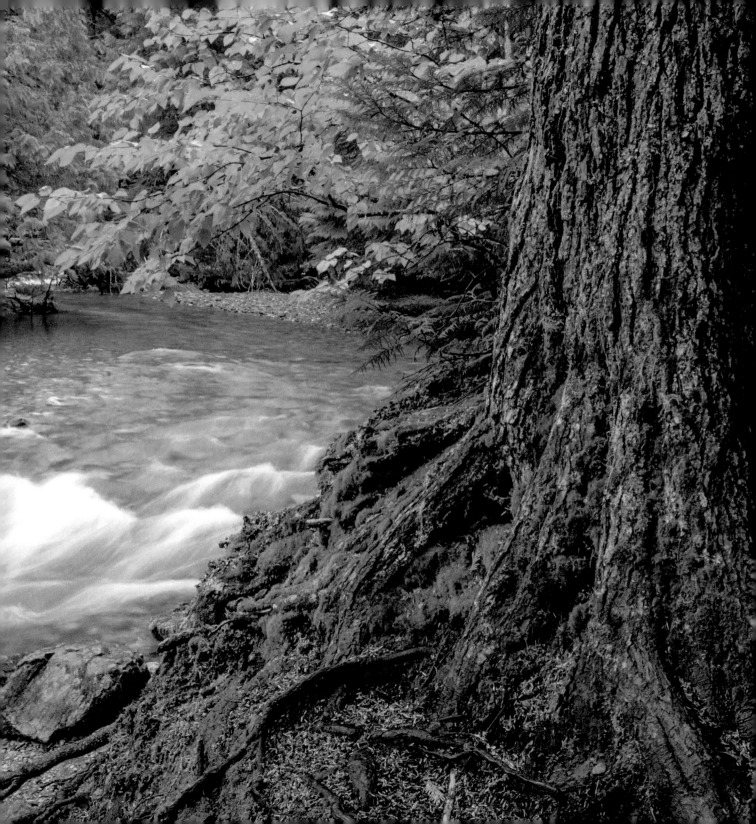

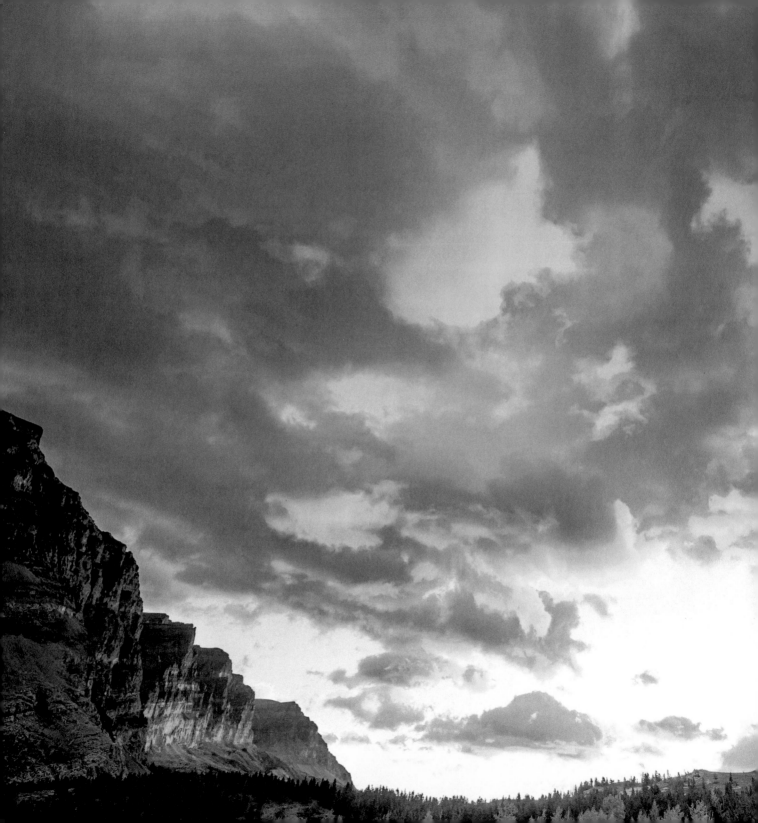

When You Need Assurance of Your Heavenly Home

Do not let your heart be troubled; believe in God, believe also in Me.
In My Father's house are many dwelling places; if it were not so, I would have told you;
for I go to prepare a place for you. If I go and prepare a place for you, I will come again
and receive you to Myself, that where I am, there you may be also.

John 14:1-3

The Lord will wipe every tear from your eyes…God encourages you to "take hold of the hope" set before you, for it anchors your soul and is sure and steadfast (Hebrews 6:18-19). The comfort in your present circumstance is that no matter the degree that your earthly dreams have been shattered, greater dreams do come true because of the Lord's eternal promises. And therein lies your great hope; and it is one that does not fade, but grows with each passing day.

A Heart to See Forever — Quiet Times for the Heart ©2003, 2011

Lord, thank You for the hope that You have prepared my home in heaven. Amen.

Retracing all the way
thy God led thee through the wilderness,
thou shalt gather material
from each mercy and from each trial,
from each joy and from each sorrow,
for an eternal hymn of praise
to His great and glorious name.
Beloved, you are learning these songs now
in the house of your pilgrimage.
As you cross the desert sands,
or break your lone footsteps
through the depth of the wilderness,
or stand within the sacred shadow of the cross,
God is preparing you for the music-mansion of glory.
All His dealings with you in providence
and in grace are but to train and attune
the powers, affections, and sympathies
of your soul to the sweet harmony of the spheres…
A harp of gold strung by angels
and attuned by Christ's own hands
awaits you in the music-mansion above,
and soon you will sweep its chords
to the high praises of the triune Jehovah
and all heaven will ring its melody.

HELP HEAVENWARD — OCTAVIUS WINSLOW

꙰

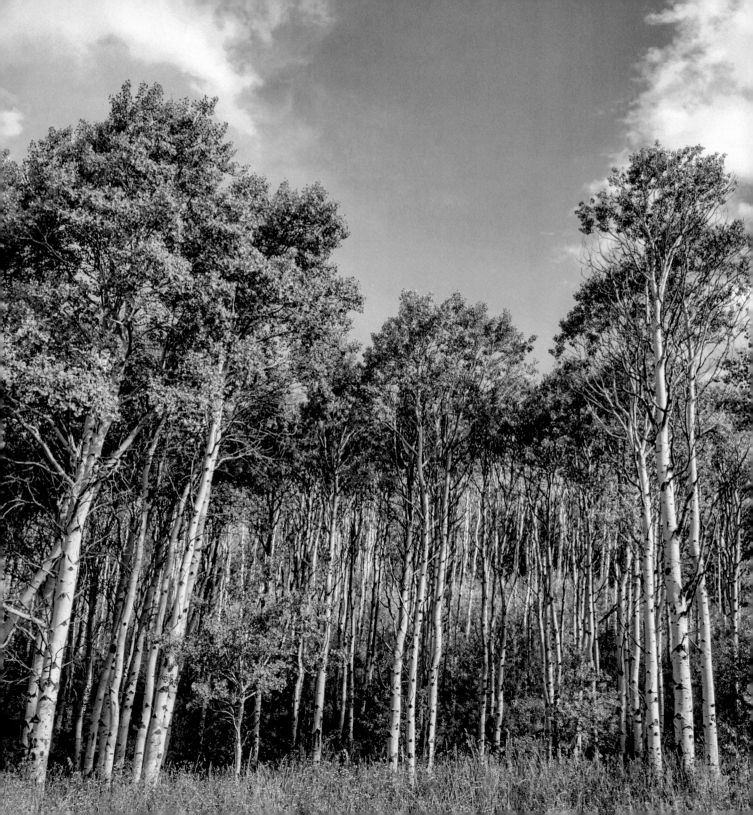

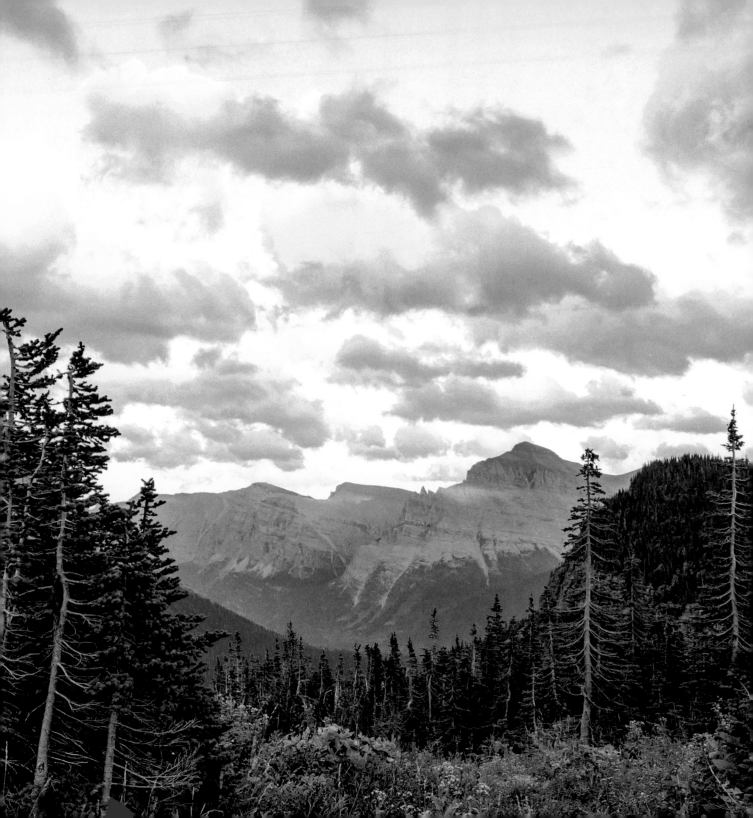

When You Need the Hope of Eternity

His bond-servants will serve Him; they will see His face…
the Lord God will illumine them; and they will reign forever and ever.
Revelation 22:3-5

Imagine looking out at the broad expanse of the ocean. Seeming to go on forever and ever, the water appears to meet the sky at the horizon. And yet what you see is not all there is. By faith, you know there is more. You just can't see it, for your view is limited. Those with hearts to see forever don't look at life or eternity from the vantage point of the here and now or feelings and emotions. No, they look instead from the firm ground of God and His Word and thus live in the eternal perspective—able to see all of life from God's point of view and live accordingly in the present. With that vantage point of the eternal clearly in view, they live with the knowledge that there is so much more that is theirs in eternity. As a result, they are filled with hope.

A Woman's Heart that Dances — A Devotional Journey ©2009

Lord, I look to my eternal home in heaven, and I am filled with hope
as You open my eyes to its beauty and wonder. Amen.

The glorified weep no more, for all outward causes of grief are gone. There are no broken friendships, nor blighted prospects in heaven. Poverty, famine, peril, persecution, and slander are unknown there. No pain, distresses, no thought of death or bereavement saddens.

They weep no more, for they are perfectly sanctified…

They weep no more, because all fear of change is past. They know that they are eternally secure. Sin is shut out, and they are shut in. They dwell within a city which shall never be stormed; they bask in a sun which shall never set; they drink of a river which shall never dry; They pluck fruit from a tree which shall never wither… They are forever with the Lord.

They weep no more, because every desire is fulfilled. They cannot wish for anything which they have not in possession.…

The joy of Christ, which is an infinite fulness of delight, is in them. They bathe themselves in the bottomless, shoreless sea of infinite beatitude. That same joyful rest remains for us…Ere long the weeping willow shall be exchanged for the palm-branch of victory, and sorrow's dewdrops will be transformed into the pearls of everlasting bliss.

Morning And Evening — Charles Haddon Spurgeon

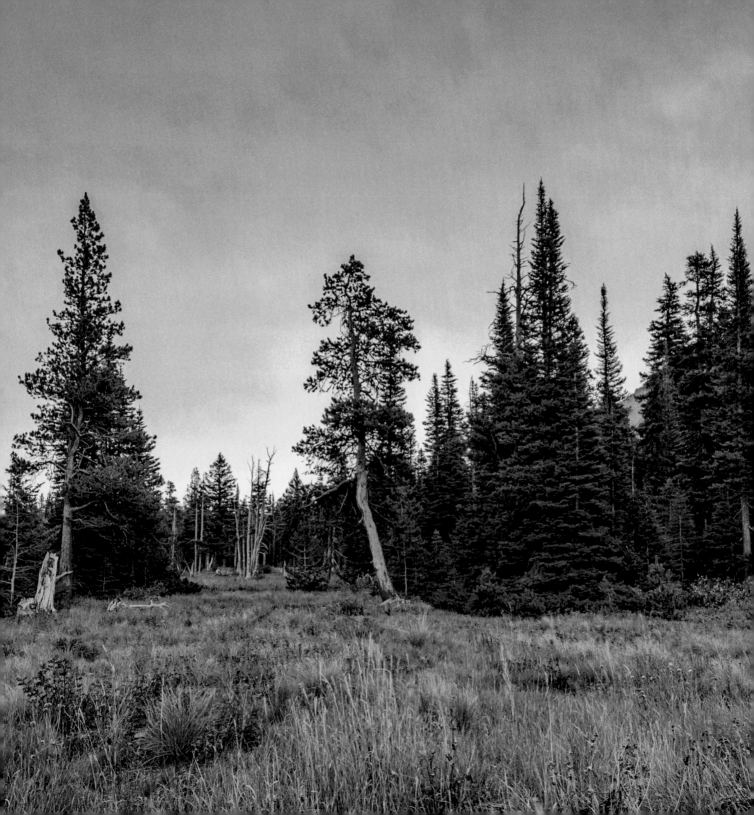

APPENDIX

myPhotoWalk SmugMug
Photography
About The Author
About myPhotoWalk
Ackowledgments
You Might Also Like

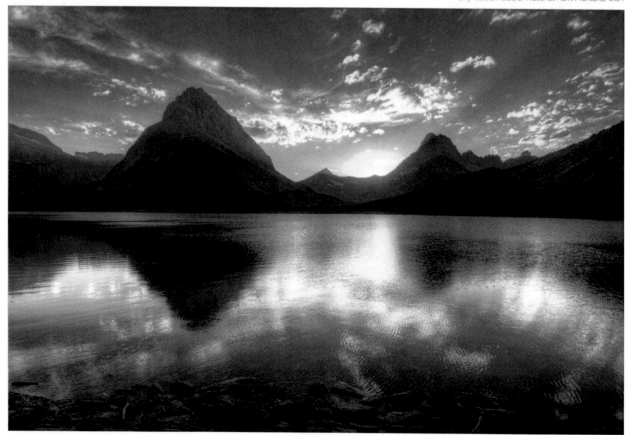

❧ PHOTOGRAPHY ☙

COVER

Cover and Interior Photography by Catherine Martin, myPhotoWalk—SmugMug, catherinemartin.smugmug.com, Custom Prints and Inspirational Gifts.

Mercy, 2012, Lower Antelope Slot Canyon, Antelope Canyon Navajo Tribal Park, Page, Arizona, USA, Nikon D7000, 18-105mm, FL 18mm, ISO 125, f/13, AEB.

31 ESSENTIAL PROMISES GIVING YOU HOPE

MYPHOTOWALK SMUGMUG GALLERIES — Catherine Martin's very favorite images of hope from photoshoots at Glacier, Zion, & Bryce National Parks, Monument Valley, Antelope Canyon, Hawaii, Tuscany, Sedona, Klamath Falls, Newport Beach, San Francisco, and Santa Fe, as well as the Mojave-Sonoran Desert. Enjoy.

Page 13: HOPE, 2016, The Rose Garden, Newport Beach, California, USA, Nikon D810, Micro-Nikkor 200mm, FL 200mm, ISO 1250, f/7.1, 1/200sec..

Page 14, Finding The Way, 2015, Carson National Forest, High Road To Taos, Taos, New Mexico, USA, Nikon D7000, Nikkor 12-24mm, FL 12mm, ISO 100, f/16, 1/50sec.

Page 17, Jesus Is The Door, 2015, Canyon Road, Santa Fe, New Mexico, USA, Sony A6000, Zeiss 16-70mm, FL 36mm, ISO 100, f/5.6, 1/200sec.

Page 18, The Way Of Escape, 2015, Canyon Road, Santa Fe, New Mexico, USA, Sony A6000, Zeiss 16-70mm, FL 20mm, ISO 100, f/6.5, 1/200sec.

Page 21, The Way Of The Cross, 2015, El Santuario de Chimayo, Chimayo, New Mexico, USA, Sony A6000, Zeiss 16-70mm, FL 16mm, ISO 100, f/11, 1/125sec.

Page 22, The Answer For Sin, 2015, Kasha-Katuwe Tent Rocks National Monument, Cochiti Pueblo, New Mexico, USA, Nikon D7000, Nikkor 24-120mm, FL 24mm, ISO 100, f/16, AEB.

Page 25, The Way To Forgiveness, 2015, Canyon Road, Santa Fe, New Mexico, USA, Nikon D7000, Nikkor 24-120mm, FL 58mm, ISO 400, f/8, 1/60sec.

Page 26, Prayer And Peace, 2012, Zion National Park, Utah, USA, Nikon D7000, Nikkor 18-105mm, FL 28mm, ISO 160, f/7.1, AEB.

Page 29, Lifted Up, 2012, Zion National Park, Utah, USA, Nikon D7000, Nikkor 18-105mm, FL 32mm, ISO 160, f/22, 1/5sec.

Page 30, Confidence In God, 2012, Virgin River, Zion National Park, Utah, USA, Nikon D7000, Nikkor 18-105mm, FL 18mm, ISO 160, f/11, AEB.

Page 33, Leaves Of Many Colors, 2012, Zion National Park, Utah, USA, Nikon D7000, Nikkor 18-105mm, FL 50mm, ISO 160, f/13, 1/50sec.

Page 34, Hope For Broken Hearts, 2012, Lower Antelope Slot Canyon, Antelope Canyon Navajo Tribal Park, Page, Arizona, USA, Nikon D7000, Nikkor 18-105mm, FL 50mm, ISO 125, f/13, AEB.

Page 37, Light In The Clouds, 2012, Horseshoe Bend, Colorado River, Glen Canyon National Recreation Area, Page, Arizona, USA, Nikon D7000, Nikkor 12-24mm, FL 22mm, ISO 125, f/11, 1/100sec.

Page 38, The Rock Of Strength, 2012, Bryce Canyon National Park, Bryce Canyon, Utah, USA, Nikon D7000, Nikkor 18-105mm, FL 32mm, ISO 160, f/13, AEB.

Page 41, Going Up To God, 2012, Dixie National Forest, Bryce Canyon National Park, Bryce Canyon, Utah, USA, Nikon D7000, Nikkor 18-105mm, FL 34mm, ISO 125, f/11, 1/8sec.

Page 42, The Place Of Rest, 2012, Totem Pole, Monument Valley Navajo Tribal Park, Oljato-Monument Valley, Utah, USA, Nikon D7000, Nikkor 18-105mm, FL 45mm, ISO 200, f/11, AEB.

Page 45, A Firm Foundation, 2012, Monument Valley Navajo Tribal Park, Oljato-Monument Valley, Utah, USA, Nikon D7000, Nikkor 18-105mm, FL 105mm, ISO 160, f/11, AEB.

Page 46, Stillness, 2012, Bryce Canyon National Park, Bryce Canyon, Utah, USA, Nikon D7000, Nikkor 70-300mm, FL 135mm, ISO 320, f/5.6, 1/125sec.

Page 49, Bryce Beauty, 2012, Bryce Canyon National Park, Bryce Canyon, Utah, USA, Nikon D7000, Nikkor 18-105mm, FL 35mm, ISO 160, f/13, 1/60sec.

Page 50, Joy In The Morning, 2016, Coachella Valley Preserve, Palm Desert, California, USA, Nikon D810, Nikkor 24-120mm, FL 120mm, ISO 6400, f/5.6, 1/8000sec.

Page 53, A Beautiful Day, 2016, Rancho California Vineyards, Temecula, California, USA, Sony A6000, Zeiss 16-70mm, FL 20mm, ISO 125, f/4, 1/60sec.

Page 54, A Good Work In You, 2016, Golden Pebble Habitat, Palm Desert, California, USA, Nikon D810, Nikkor 50mm, FL 50mm, ISO 800, f/2.2, 1/400sec.

Page 57, A Step Of Faith, 2016, Rancho California Vineyards, Temecula, California, USA, Nikon D810, Nikkor 24-120mm, FL 70mm, ISO 800, f/4.5, AEB.

Page 58, No More Tears, 2016, The Rose Garden, Newport Beach, California, USA, Nikon D810, Lensbaby Velvet 56, FL 56mm, ISO 400, f/5.6, 1/250sec.

Page 61, Sands Of Time, 2016, Coachella Valley Preserve, Palm Desert, California, USA, Sony A6000, Zeiss 16-70mm, FL 24mm, ISO 800, f/8, 1/60sec.

Page 62, Far More Abundantly, 2016, Golden Pebble Habitat, Palm Desert, California, USA, Nikon D810, Micro-Nikkor 200mm, FL 200mm, ISO 3200, f/11, 1/250sec.

Page 65, Trust In The Dark, 2011, San Jacinto Mountains, Coachella Valley, Palm Springs, California, USA, Nikon D7000, Nikkor 18-105mm, FL 48mm, ISO 250, f/4.8, 1/200sec.

Page 66, Time Is In His Hands, 2015, Muir Woods National Monument, Mill Valley, California, USA, Sony A6000, Zeiss 16-70mm, FL 16mm, ISO 640, f/4, 1/160sec.

Page 69, Reflections From Above, 2015, Muir Woods National Monument, Mill Valley, California, USA, Sony A6000, Zeiss 16-70mm, FL 42mm, ISO 1600, f/4, 1/160sec.

Page 70, When God Revives, 2015, Hagiwara Tea Gardens, DeYoung Museum, Golden Gate Park, San Francisco, California, USA, Nikon D810, Nikkor 24-120mm, FL 78mm, ISO 400, f/8, 1/800sec.

Page 73, Relief For Thirsty Souls, 2015, Vista Point, Golden Gate Bridge, San Francisco Skyline, Sausalito, California, USA, Sony A6000, Zeiss 16-70mm, FL 68mm, ISO 100, f/11, 1/320sec.

Page 74, Always Hope, 2015, Oak Creek Canyon, Sedona, Arizona, USA, Nikon D800E, Nikkor 24-120mm, FL 38mm, ISO 1000, f/11, 1/25sec.

Page 77, Well With My Soul, 2013, Cathedral Rock, Sedona, Arizona, USA, Nikon D7000, Nikkor 12-24mm, FL 16mm, ISO 100, f/11, AEB.

Page 78, Patient Waiting, 2016, Courthouse Butte, Sedona, Arizona, USA, Nikon D810, Nikkor 24-120mm, FL 24mm, ISO 100, f/22, AEB.

Page 81, Surprising Light Of The Lord, 2016, Bell Rock—Courthouse Butte, Sedona, Arizona, USA, Nikon D810, Micro-Nikkor 200mm, FL 200mm, ISO 400, f/6.3, 1/3200sec.

Page 82, The Story Of Your Life, 2015, Coachella Valley Preserve, Palm Desert, California, USA, Nikon D800E, Nikkor 24-120mm, FL 120mm, ISO 100, f/11, AEB.

Page 85, When The Way Becomes Clear, 2016, Coachella Valley Preserve, Palm Desert, California, USA, Sony A6000, Zeiss 16-70mm, FL 25mm, ISO 100, f/5, 1/60sec.

Page 86, God Works Things Together For Good, 2013, Bill Williams River National Wildlife Refuge, Lake Havasu City, Arizona, USA, Nikon D7000, Nikkor 18-105mm, FL 98mm, ISO 100, f/11, AEB.

Page 89, A Greater Plan, 2013, Colorado River, Lake Havasu City, Arizona, USA, Nikon D7000, Nikkor 18-105mm, FL 105mm, ISO 100, f/11, AEB.

Page 90, Conquering Through Christ, 2011, Castello Rocca Maggiore, Assisi, Umbria, Italy, Nikon D7000, Nikkor 18-105mm, FL 62mm, ISO 200, f/11, 1/400sec.

Page 93, My Jesus I Love Thee, 2011, Boboli Gardens, Palazo Pitti, Florence, Tuscany, Italy, Nikon D7000, Nikkor 70-300mm, FL 145mm, ISO 250, f/5.6, 1/1600sec.

Page 94, Looking To God For Help, 2011, San Gimignano, Siena, Tuscany, Italy, Nikon D7000, Nikkor 18-105mm, FL 24mm, ISO 200, f/7.1, 1/200sec.

Page 97, The Open Gate, 2011, Principe Corsini Villa Le Corti, Val Di Pesa, Florence, Tuscany, Italy, Nikon D7000, Nikkor 18-105mm, FL 52mm, ISO 250, f/7.1, 1/400sec.

Page 98, God Never Forgets You, 2011, Montepulciano, Siena, Tuscany, Italy, Nikon D7000, Nikkor 18-105mm, FL 42mm, ISO 250, f/11, 1/320sec.

Page 101, Jesus Always With Me, 2011, Ente Diocesi Di Montepulciano-Chiusi-Pienza, Montepulciano, Siena, Tuscany, Italy, Nikon D7000, Nikkor 18-105mm, FL 50mm, ISO 250, f/10, 1/320sec.

Page 102, Mercy And Grace, 2012, Pauoa Bay, Waimea, Island Of Hawaii, Hawaii, USA, Nikon D7000, Nikkor 18-105mm, FL 18mm, ISO 100, f/8, 1/250sec.

Page 105 Sparkling Grace, 2012, Mauna Lani Terrace, Pauoa Bay, Waimea, Island of Hawaii, Hawaii, USA, Nikon D7000, Nikkor 50mm, FL 50mm, ISO 160, f/3.5, 1/1600sec.

Page 106, The Gift Of Grace, 2012, Hawaii Tropical Botanical Garden, Papaikou, Island Of Hawaii, Hawaii, USA, Nikon D7000, Nikkor 50mm, FL 50mm, ISO 160, f/1.6, 1/1600sec.

Page 109, A Carpet Of Flowers, 2012, Mauna Lani Terrace, Pauoa Bay, Waimea, Island of Hawaii, Hawaii, USA, Nikon D7000, Nikkor 50mm, FL 50mm, ISO 160, f/3.5, 1/1600sec.

Page 110, God's Spirit Resting On You, 2012, Pauoa Bay, Waimea, Island Of Hawaii, Hawaii, USA, Nikon D7000, Nikkor 12-24mm, FL 12mm, ISO 200, f/7.1, 1/200sec.

Page 113, Footsteps In The Sea, 2012, Pauoa Bay, Waimea, Island Of Hawaii, Hawaii, USA, Nikon D7000, Nikkor 18-105mm, FL 66mm, ISO 100, f/5.6, 1/500sec.

Page 114, God Will Take Care Of You, 2016, Corona Del Mar State Beach, Corona Del Mar, Newport Beach, California, USA, Nikon D810, Nikkor 80-400mm, FL 400mm, ISO 100, f/5.6, 1/400sec.

Page 117, Looking To The Lord, 2016, Corona Del Mar State Beach, Corona Del Mar, Newport Beach, California, USA, Nikon D810, Nikkor 80-400mm, FL 175mm, ISO 1600, f/11, 1/5000sec.

Page 118, He Strengthens Me, 2016, Corona Del Mar State Beach, Corona Del Mar, Newport Beach, California, USA, Nikon D810, Nikkor 80-400mm, FL 370mm, ISO 100, f/8, 1/160sec.

Page 121, Strong In The Lord, 2015, La Jolla Shores, La Jolla, California, USA, Nikon D810, Nikkor 24-120mm, FL 62mm, ISO 64, f/22, 1/400sec.

Page 122, Set Free, 2016, Corona Del Mar State Beach, Corona Del Mar, Newport Beach, California, USA, Nikon D810, Nikkor 80-400mm, FL 390mm, ISO 100, f/5.6, 1/400sec.

Page 125, The Wind In My Sails, 2016, Corona Del Mar State Beach, Corona Del Mar, Newport Beach, California, USA, Nikon D810, Nikkor 80-400mm, FL 400mm, ISO 400, f/5.6, 1/4000sec.

Page 126, Renewed Day By Day, 2013, St. Mary Valley, Glacier National Park, Montana, USA, Nikon D7000, Nikkor 18-105mm, FL 98mm, ISO 100, f/29, 1/15sec.

Page 129, Immeasurable Grace, 2013, Avalanche Lake Trail, Glacier National Park, Montana, USA, Nikon D7000, Nikkor 12-24mm, FL 24mm, ISO 100, f/22, 0.8sec.

Page 130, A Place For You, 2013, Many Glacier, Glacier National Park, Montana, USA, Nikon D7000, Nikkor 12-24mm, FL 12mm, ISO 100, f/11, 1/10sec.

Page 133 Toward The Heavenly Homeland, 2013, East Glacier Park, Glacier Park Lodge, Glacier National Park, Montana, USA, Nikon D7000, Nikkor 12-24mm, FL 14mm, ISO 100, f/11, 1/50sec.

Page 134, Forever And Ever, 2013, Logan Pass, Glacier National Park, Montana, USA, Nikon D7000, Nikkor 12-24mm, FL 24mm, ISO 100, f/11, 1/8sec.

Page 137, Everlasting Bliss, 2013, East Glacier Park, Glacier Park Lodge, Glacier National Park, Montana, USA, Nikon D7000, Nikkor 12-24mm, FL 16mm, ISO 100, f/7.1, 1/25sec.

About the Author

Catherine Martin is a summa cum laude graduate of Bethel Theological Seminary with a Master of Arts degree in Theological Studies. She is founder and president of Quiet Time Ministries, a director of women's ministries for many years, and an adjunct faculty member of Biola University. She is the author of *Six Secrets to a Powerful Quiet Time, Knowing and Loving the Bible, Walking with the God Who Cares, Set my Heart on Fire, Trusting in the Names of God, Passionate Prayer, Quiet Time Moments for Women,* and *Drawing Strength from the Names of God* published by Harvest House Publishers, and *Pilgrimage of the Heart, Revive My Heart* and *A Heart That Dances,* published by NavPress. She has also written *The Quiet Time Notebooks, Walk on Water Faith, A Heart on Fire, A Heart to See Forever, Run Before the Wind,* and *A Heart That Hopes in God,* published by Quiet Time Ministries Press. She is founder of myPhotoWalk.com dedicated to the art of devotional photography publishing *myPhotoWalk—Quiet Time Moments.* As a popular keynote speaker at retreats and conferences, Catherine challenges others to seek God and love Him with all of their heart, soul, mind, and strength. For more information about Catherine Martin, please visit www.quiettime.org and www.myphotowalk.com.

About Quiet Time Ministries

Quiet Time Ministries is a nonprofit religious organization under Section 501(c)(3) of the Internal Revenue Code. Cash donations are tax deductible as charitable contributions. We count on prayerful donors like you, partners with Quiet Time Ministries pursuing our goals of the furtherance of the Gospel of Jesus Christ and teaching devotion to God and His Word. Visit us online at www.quiettime.org to view special funding opportunities and current ministry projects. Your prayerful donations bring countless project to life!

Quiet Time Ministries | P.O. Box 14007 | Palm Desert, California 92255
1.800.925.6458 | catherine@quiettime.org | www.quiettime.org | www.myphotowalk.com

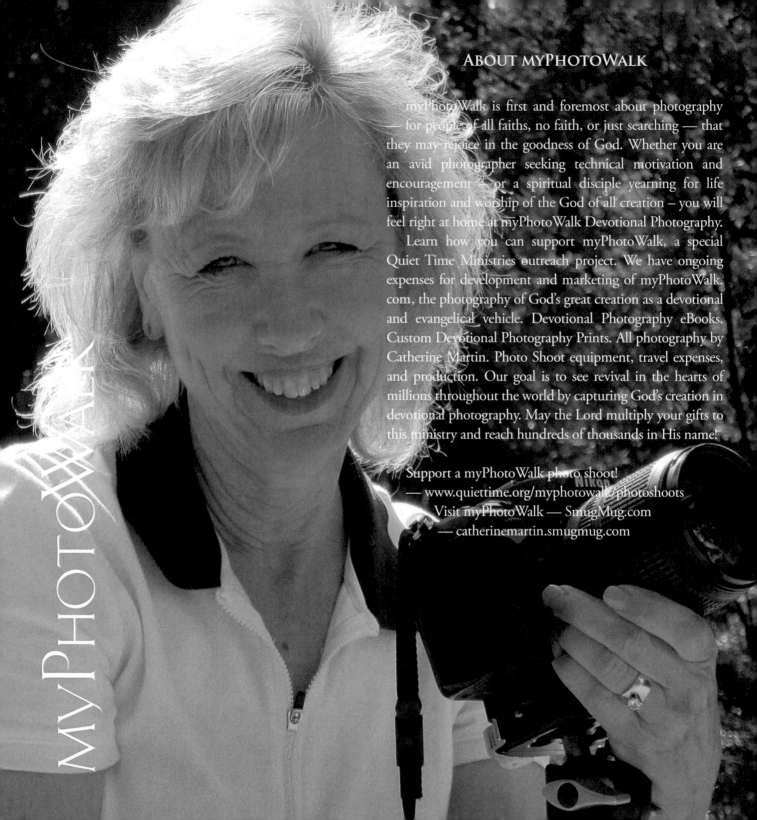

ABOUT myPHOTOWALK

myPhotoWalk is first and foremost about photography — for people of all faiths, no faith, or just searching — that they may rejoice in the goodness of God. Whether you are an avid photographer seeking technical motivation and encouragement — or a spiritual disciple yearning for life inspiration and worship of the God of all creation – you will feel right at home at myPhotoWalk Devotional Photography.

Learn how you can support myPhotoWalk, a special Quiet Time Ministries outreach project. We have ongoing expenses for development and marketing of myPhotoWalk. com, the photography of God's great creation as a devotional and evangelical vehicle. Devotional Photography eBooks. Custom Devotional Photography Prints. All photography by Catherine Martin. Photo Shoot equipment, travel expenses, and production. Our goal is to see revival in the hearts of millions throughout the world by capturing God's creation in devotional photography. May the Lord multiply your gifts to this ministry and reach hundreds of thousands in His name!

Support a myPhotoWalk photo shoot!
— www.quiettime.org/myphotowalk/photoshoots
Visit myPhotoWalk — SmugMug.com
— catherinemartin.smugmug.com

myPHOTOWALK